Angels

*from Dante Rossetti
to Paul Klee*

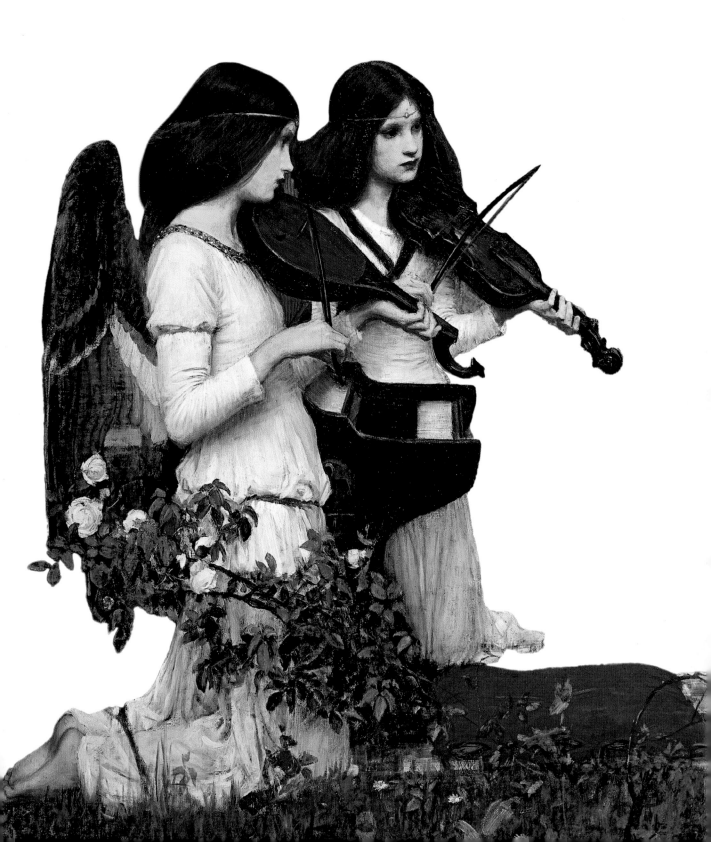

Angels from Dante Rossetti to Paul Klee

Ruth Langenberg

PRESTEL

MUNICH | LONDON | NEW YORK

Angels *in* the Art *and* Culture *of the* Nineteenth Century

Angels are indeed incorporeal beings, and yet Man has always been tempted by the idea of trying to imagine what these heavenly creatures look like. Even in classical times we find winged goddesses of victory, Nikes and Victories, who would later become the prototype for Christian angels. The cupids of antiquity have also found their way into Christian art in the form of cherubs or *putti*.

These models were important because the stories in the Bible provide us with very few details regarding the appearance of the divine messengers. They are often described as masculine and sometimes as wearing white robes; winged creatures are only mentioned in con-nection with cherubim and seraphim. Angels are not defined so much by their appearance as by their function as the messengers of God – and indeed the name is derived from the Greek word *angeloi* – "messenger." The best-known example of the angel as messenger is the Arch-angel Gabriel, who brings the Virgin Mary the news of the birth of the Messiah. There are also reports of angels intervening in events here on Earth: thus in one scene in the Old Testa-ment, an angel stands in the path of the prophet Balaam and prevents his passage (see fig. p. 5). Angels act as mediators between God and Man, between the visible and the invisible world, between the here-and-now and the world beyond. Wings appear to be a useful accessory

"How presumptuous to give a form to a disembodied being! And yet we are attracted by the idea of imagining a heavenly creature in our mind's eye." [1]

(NEILOS SCHOLASTIKOS, 6TH CENTURY
Epigram on an Archangel)

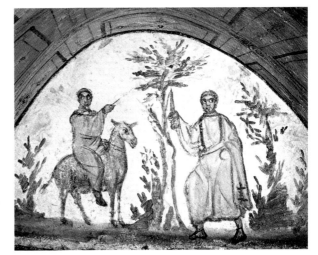

Balaam Stopped by the Angel
(Mid 4th century)
Mural in sepulchral niche
Catacombs of the Via
Latina, Rome
In the first centuries of Christianity, angels were represented without wings. Here, an angel armed with a knife blocks the prophet Balaam's path.

for this role as go-between, but it was not until about AD 400 that angels began to be represented with wings. Until then they were mostly depicted simply as men in white robes.

By the nineteenth century artists could draw on a long and rich tradition of pictorial representations of angels. Nonetheless, the spiritual assumptions behind their portrayals differed fundamentally from those of previous centuries. Secularization and the Enlightenment had led to a questioning of the religious thought which had hitherto provided essential guidance, and the weakened position of the Church exacerbated the problems in this respect. Many people experienced doubts as a result of the increasing influence of capitalism, scientific positivism, industrialization, and the attendant urbanization, not to mention the new theories such as those of Darwin and Freud. At the same time the crisis also led to a new search for the transcendental, because many people were not prepared to accept a concept of humanity that could exist without a spiritual link to the divine. Thus the Christian religion became topical again – albeit in a different way – and at the same time other religions and esoteric groupings gained increasing numbers of supporters.

In the wake of the Enlightenment, angels or demons were relegated by nineteenth-century theology to a secondary position in the realms of

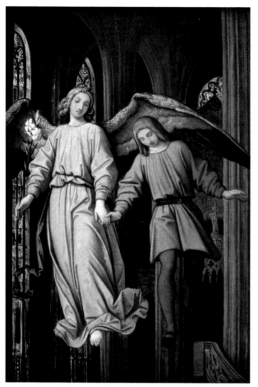

**MORITZ VON
SCHWIND**

*"The Dream of Erwin von
Steinbach" (c. 1845)*
Oil on cardboard,
36.4 x 25.3 cm
Bayerische Staatsgemälde-
sammlungen, Munich,
Sammlung Schack

the fairy tale and pious legends. They were described as "metaphysical bats," and as such were relevant only for poets and painters.[2] Yet despite – or perhaps because of – this lack of attention paid to the winged messenger within the Church, angels continued to play an important role in nineteenth-century culture. On the one hand they became part of the expanding esoteric-mystic movements like those of Helena Blavatsky or Rudolf Steiner, and on the other they also cropped up in everyday culture and public life. In the bourgeois culture of the nineteenth century, angels now fulfilled people's longing for the transcendental, without being directly tied to the Church and its dogma. "Thus angels become symbols of a denied desire, of a longing which the enlightened world had banished into the realm of the irrational."[3] At the same time, there was a real renaissance in the belief in guardian angels. Children in particular were portrayed in the company of their personal guardian angel, for example when saying their prayers at night.

Angels also played a part in history painting. They not infrequently contributed to the Christian interpretation of history, as in the dramatic scene portrayed by Wilhelm von Kaulbach in the monumental painting *The Destruction of Jerusalem by Titus* (see fig. pp. 42/43). People also encountered large numbers of winged spirits on public monuments and memorials, where they harked back to the goddesses of antiquity and represented Victory or Peace. Angels appeared regularly on tombs and gravestones during the nineteenth century. Here they can be traced back to a concept familiar from antiquity: the idea that the soul of the deceased was accompanied into the hereafter by an angel. Nineteenth-century angels were influenced by classicism and generally expressed mourning and an elegiac mood (see fig. p. 59).

Romantic art can be seen as a forerunner of Symbolism. Romantic artists sought "salvation from a reality torn apart by mechanistic reason, a world which had been transformed during the Enlightenment into machinery and cogs."[4] They saw it as their task to open people's eyes to the world "behind" what could actually be seen, to understand pictures as expressions of subjective moods. In his cycle of the four Times of Day (*Morning, Day, Evening, Night*, see fig. p. 31) Philipp Otto Runge achieved a synthesis of models derived from both Christianity and antiquity. In the picture of *Morning*, cherubs, familiar from antiquity as cupids, surround Aurora as the symbol of the day which is just dawning. They create a roundelay as they mediate between the earthly and the heavenly spheres, ending in a gloriole of angels. Thus they make visible the totality of the divine creation – and the creation as divine.

As a representative of Late Romanticism, the Munich artist Moritz von Schwind presents us with an angel hovering in a Gothic church

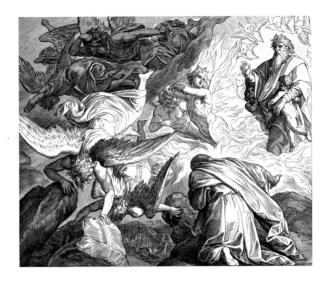

(see fig. p. 6). In his right hand he holds a lily, which identifies him as the Angel Gabriel in the scene of the Annunciation. With his left hand he holds that of the master builder Erwin von Steinbach; the latter was seen as the epitome of the Gothic architect, thanks to Goethe's work *On German Architecture*. The picture shows the process of inspiration, which took place while the architect was asleep. The angel becomes a genius who tells him in a dream how he should build Strasbourg Cathedral. Von Schwind thus linked the concept of genius with the Angel of the Annunciation and at the same time with the figure of the guardian angel spreading his wings out above Man.

The aim of the Nazarenes was the renewal of art through a return to older artistic styles. They were an association of painters who took as their models the works of artists from medieval Germany and the early Italian Renaissance. The latter period embodied, in their view, an ideal of authenticity. One of the members of the group was Peter von Cornelius (see fig. p. 34), who created a fresco of the Last Judgment in the Ludwigskirche (Church of St. Louis) in Munich, one of the largest and most impressive altar frescoes ever painted.

The angels created by Julius Schnorr von Carolsfeld are equally impressive. In his monumental Bible, illustrated with 240 woodcuts (see fig. above), the scenes showing angels influenced the image of angels during this time. In France, Gustave Doré (see figs. pp. 8, 52) was highly successful with his atmospheric Bible illustrations.

Another of the most important precursors of the new image of the angel was the English artist William Blake (see figs. pp. 9, 28). He created completely new and powerful angelic figures based on the art of antiquity and Michelangelo, evoking a noble vision of artistic inspiration. As in early Christianity, Blake's angels are sometimes shown without wings.

In a painting by the English artist J. M. W. Turner, the angel appears closely linked with the powers of nature (see fig. p. 41). The picture shows an angel completely surrounded by divine light. Painted in a manner which

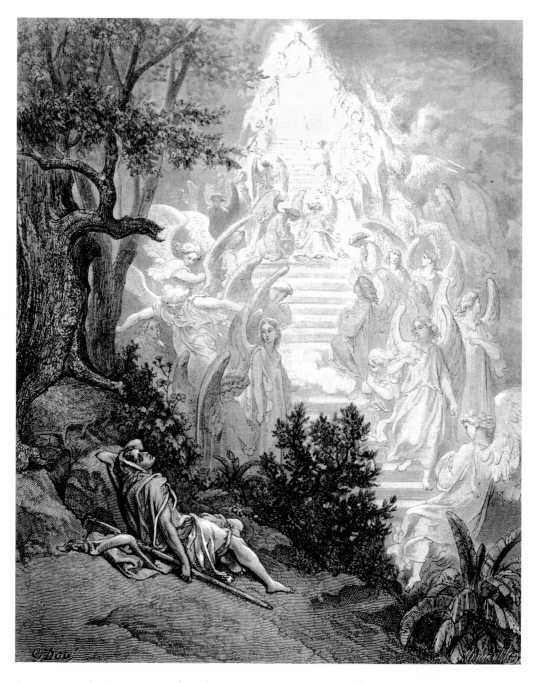

GUSTAVE DORÉ | *"Jacob's Dream" (1866)*
Woodcut, 35 x 25 cm
From: *Illustrated Bible,* Mame & Fils, Tours
*In a dream, God the Father appears to Jacob. A ladder (depicted here as a staircase)
on which angels ascend and descend leads towards him (Genesis 28).*

was extraordinarily pastose for the time, it seems as if the contours have been almost entirely dissolved.

The close connection between angels and light, the concept of the angel as a "shining light," is repeated in numerous pictures during the nineteenth century. Light is the immaterial substance par excellence, permitting all material objects to be seen in the first place. But at the same time it also stands for the Light of God, and Christ is also often described as the bringer of light.

ANGELS IN SYMBOLIST ART

Symbolist art developed during the period around the end of the nineteenth and beginning of the twentieth century. The Berlin art critic Max Osborn described the particular mood it evoked very aptly: "The mystic and the magical became attractive once more. Everything which was focused towards the hereafter was taken up with enthusiasm. Large, sect-like communities like those of the theosophists and anthroposophists, raised their heads. And over everything hovered a glowing new sympathy for the problems of religion. The metaphysical need, having suddenly been reawakened, grasped every means it could catch hold of."[5]

Like Romanticism, Symbolism regarded itself as a counter-movement to the materialist-rationalist thought which was seen as being embodied in realist and naturalist art, as well as in Impressionism. The realist artist Gustave Courbet was convinced that it was just not possible to depict angels because they could not be seen. Standing in front of the representations of angels by Eugène Delacroix in the church of Saint-Sulpice in Paris (see fig. p. 37), he reputedly said: "Show me an angel and I'll paint it." It is possible that his fellow artist Édouard Manet, working in the naturalist idiom, painted his picture of the dead Christ being carried by angels (see fig. p. 51) as a pictorial answer to this observation.

Symbolism began as a literary trend in France but soon manifested itself in art as well and went on to acquire numerous followers throughout Europe. The universal exhibitions contributed in no small measure to this expansion. They attracted a great deal of attention and provided a stage on which the works of Symbolist artists were shown. The beginning of the movement in the strict sense is seen as coinciding with the *Symbolist Manifesto* by the French poet Jean Moréas. He wrote in *Le Figaro* in 1886: "The goal of Symbolist art is never to express an ideal, but its sole purpose is to express itself for the sake of being expressed."[6] Thus the symbol ultimately remains ambivalent; it is suggestive and thus leaves scope for the imagination.

In contrast to the naturalist and realist artists, the Symbolists were concerned with the expression of the subconscious, the dream, the supernatural, the irrational, and the fantastic and – repeatedly – the spiritual. They created a link to the religious without being tied to the

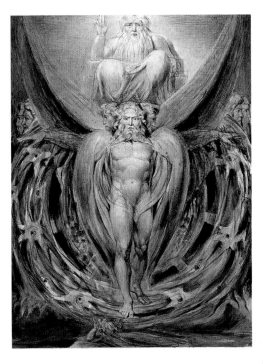

WILLIAM BLAKE
"The Whirlwind: Ezekiel's Vision of the Cherubim and Eyed Wheels"
(c. 1803–1805)
Pen, ink and watercolor on paper, 39.5 x 29 cm
Museum of Fine Arts, Boston

9

dogma of the Church. Angels, as creatures from the immaterial afterlife, accordingly proved an ideal subject for paintings, as they represented an ideal antithesis to the visible, scientifically explorable reality. The divine messengers were employed by some artists in the sense of a renewal of Christian art; they frequently also served as bearers of subjective moods.

The Pre-Raphaelites

The English Pre-Raphaelites are among the principal forerunners of the Symbolists. Edward Burne-Jones, often considered to be a Symbolist painter, produced the most impressive portrayals of angels of the era. In 1848 the artists William Holman Hunt, Dante Gabriel Rossetti, John Everett Millais and others formed a casual association in London known as the Pre-Raphaelite Brotherhood. In a second phase, beginning in 1857, they were joined by other artists including William Morris, Edward Burne-Jones, and Simeon Solomon. Like the Nazarenes, whom they greatly admired, the Pre-Raphaelites aimed to renew art beyond the boundaries set by the formal academies. They, too, were searching for a "primal," pure, unspoiled art which they found represented in the works produced during the early Italian Renaissance before Raphael, and in the Middle Ages. They considered these early forms of art to be the expression of direct religious emotions. At the same time, the Pre-Raphaelites wanted to create with their art an alternative to Victorian society, to industrialization and unregulated greed for profit. The English artists created dream worlds, in which angels played an important part. As Edward Burne-Jones explained: "… the more materialistic science becomes, the more I shall paint angels: their wings are my protest in favour of the immortality of the soul."[7]

Like the later French Symbolists, the Pre-Raphaelites found inspiration in the literature of their time and sought a new direction for their art through this source. Dante Gabriel Rossetti was the driving force within the group, particularly during the early phase. His enthusiasm for the culture of the Middle Ages did not apply solely to art, but also lay in the poetry of that era. Thus Rossetti translated Dante's partly autobiographical *Vita Nuova*, identifying himself with the personality of the Italian poet. This fascination found artistic expression in works like *Dante's Dream* and *Dantis Amor* (see figs. pp. 46, 47).

Rossetti's presentation of the Annunciation to the Virgin Mary was regarded by his contemporaries as being highly provocative. In the picture *Ecce Ancilla Domini!* (see fig. p. 44), the Virgin crouches on her bed in the corner of the room, totally alarmed by the appearance of the angel. In one hand Gabriel holds a lily, which forms part of the traditional iconography, but the stalk is directed precisely towards the Virgin's lap, thereby creating a sexual, almost aggressive tension. In his portrayal of the angel we can clearly see Rossetti's attempt to return to a representation which he saw as being Christian in origin: as in early Christian art he presented the angel without wings and clad in a white, antique-style tunic.

With its light color scheme and the clear, symmetrical composition, this picture revealed the influence of early Italian Renaissance art. A picture by John Everett Millais (see fig. p. 12), on the other hand, demonstrates the way the Pre-Raphaelites also found inspiration in Gothic art. They regarded that era as a particularly spiritual one: the Gothic revival aimed to help bring about a renewal of Christian values, through the adoption of forms that were to appeal directly to both the emotions and the intellect. Millais's design harked back to the building of a church. Through the interweaving of the Gothic architecture with figures of angels, the spirituality of the Gothic age was demonstrated in a highly individual manner.

Many of the works by Edward Burne-Jones, the most important English artist in this context, were also inspired by medieval art. More than any of the other Pre-Raphaelites, his prime interest lay in the renewal of Christian art. Before devoting himself to art, Burne-Jones studied Theology at Oxford, where he met William Morris. He joined the Pre-Raphaelite Brotherhood in London and became a pupil of Rossetti. Like Rossetti, he worked from 1861 as a designer for William Morris's newly founded company *Morris, Marshall, Faulkner & Co*. Morris's goal was to produce high-quality objects modeled on medieval crafts which would also satisfy the highest artistic requirements. He saw these works of "genuine and attractive nature"[8] as the opposite of industrially manufactured goods. Thus the company made stained-glass windows for churches and private rooms, tapestries, ceramics, book illustrations, wallpaper, and fabrics. In the field of stained-glass windows in particular, Morris initiated a renewal of the genre with designs by Burne-Jones, Rossetti and other artists which harked back to medieval models (see figs. pp. 13, 54).

Among the tapestries, it was the *Adoration of the Magi* (see fig. pp. 78/79) which was in greatest demand. The first commission for the tapestry was issued in 1886 by the Rector of Exeter College in Oxford, where William Morris had studied.

In contrast with the traditional iconography, which describes the Three Kings as following the star, here an angel is holding the star in his hand like a precious object. Together with the Kings he gazes quietly and reverently at the newborn Infant. Hovering just above the ground and dressed in a light-colored liturgical robe, he is the central figure in the picture and provides a vertical division within the composition. The statue-like interpretation of the picture as a whole is very much in the tradition

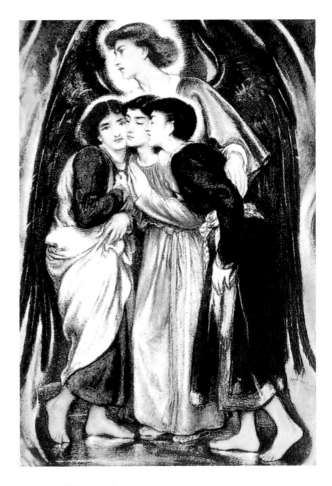

SIMEON SOLOMON
"Shadrach, Meshach and Abednego" (1863)
Watercolor, 33 x 23 cm
The Hearn Family Trust, New York
In this scene from the Book of Daniel, one of God's angels saves Shadrach, Meshach and Abednego from death in a furnace King Nebuchadnezzar wanted to burn them alive because they refused to worship his god.

JOHN EVERETT MILLAIS

"Design for a Gothic Window" (1853)
Charcoal and sepia, washed with white and green highlights, paper on canvas, 213 x 277 cm
Andrew Lloyd Webber Collection
This sketch was probably inspired by the poem The Palace of Art *by Alfred Lord Tennyson.*

of Byzantine art. The flowers, robes, jewelry and weapons, by contrast, are lovingly depicted in great detail and recall medieval tapestries. Together they make the "beauty of the Christian mystery tangible."[9]

A further source of inspiration for Burne-Jones, especially in the 1870s, was the art of the early Italian Renaissance, especially that of Botticelli. In his innovative portrayal of the *Creation* (see figs. pp. 56, 57), each day of the Creation is represented by an angel holding a crystal ball. They have flames above their heads as a particular sign of wisdom. The prophetic balls depict various scenes of the Creation. Balls of crystal or glass were familiar to artists of the time from occult practices and were also shown elsewhere in connection with angels, as in the enigmatic pictures of angels by the English Symbolist George Frederic Watts, or later in the works of James Tissot (see figs. pp. 74, 75). Occult practices and theories were quite fashionable at the time, since they possessed an aura of mystery in a world in which all illusions were regarded as having been shattered.

Apart from the Bible and the works of Dante, it was the Arthurian legends that provided the most important literary source for the Pre-Raphaelites. Rossetti and Burne-Jones made a study of this material in numerous paintings, stained-glass windows, and tapestries. In almost all the representations by Burne-Jones on this subject, angels played a central role, even when they were not strictly necessary in the context.

In the tapestry *The Failure of Sir Gawain and Sir Ewain to Achieve the Holy Grail* (see fig. p. 98), an angel protects the Holy Grail, shining in the chapel, from the knights. They have no access to it because they are still encumbered by worldly things. The tapestry *The Achievement of the Grail* (see fig. p. 99) shows three angels with broad red wings, clad in light liturgical vestments, standing facing the viewer. Armed with spears, they refuse access to Sir Bors and Sir Percival but allow Sir Galahad to enter. The latter knight kneels before the temple of the Grail on the right-hand edge of the picture, in which three angels in white robes worship before the chalice of the Last Supper.

WILLIAM MORRIS, AFTER DESIGNS BY DANTE GABRIEL ROSSETTI AND EDWARD BURNE-JONES
"Seraphim" (1870)
Stained-glass window
Bradford Art Galleries and Museums, West Yorkshire

13

Symbolists in France and Belgium

Before long the art of the Pre-Raphaelites gained recognition beyond the borders of England, especially in France. At the Universal Exposition in Paris in 1855 and at subsequent universal exhibitions, the works of Holman Hunt, John Everett Millais, Edward Burne-Jones and others were greatly admired. "Burne-Jones is the man of the minute; people believe that they have found in him the crown witness for aestheticism, refined decadence and sensitivity and the new spirituality of Symbolism. His asexual figures from the sagas and myths appear not of this world as they ignore the sordid characteristics of our century."[10] For many French artists, the Pre-Raphaelites were models for their own striving to express the spiritual world of dreams and visions.

The occult and esoteric tendencies of the time were concentrated in the Salon de la Rose+Croix. This loose association of lay people under the leadership of Joséphin Péladan made a study of the Rosicrucians, as well as of alchemy and the different popular religions. Their fundamental premise was that all religions shared the same basic foundation. Péladan organized exhibitions known as the *Salon de la Rose+Croix.* Here works were displayed by artists who also adopted new ways of depicting angels, including Carlos Schwabe, James Tissot, Ferdinand Hodler, Paul Gauguin, and a number of representatives of Les Nabis. The aim of the exhibitions was to counter materialistic attitudes and art with a spiritual, idealistic form of art.

It was the presence of writers and theoreticians like Baudelaire, Mallarmé, Aurier and Denis, combined with the opportunities for studying international art, that made France, and especially Paris, the starting point for the Symbolist movement. One of the precursors of Symbolism was the painter Gustave Moreau, who like many others was influenced by the English Pre-Raphaelites. Moreau rebelled against the currents of realism and Impressionism, seeing art as a means of reflecting the internal, the imaginary and the supernatural spheres. The sources of his pictorial inventions were frequently classical mythology and Christian themes.

Moreau's portrayal of the fight between *Jacob and the Angel* (see fig. p. 15) is quite different from that of Eugène Delacroix (see fig. p. 37). Moreau did not show an embittered struggle but interpreted the scene as a mental, internal conflict. Against the backdrop of a night landscape the angel is shown standing quietly and passively. In complete contrast with this static figure, Jacob is shown with flowing hair, blindly struggling against an unseen power. The angel, on the other hand, does not fight, but places his right hand on Jacob's arm and becomes his guide. The physical strength which is evident in the Michelangelesque figure of Jacob appears powerless in the face of the superior, commandingly moral power of the angel. Moreau also

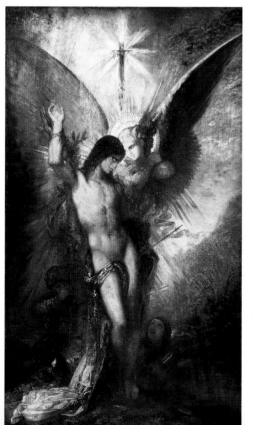

GUSTAVE MOREAU
"Saint Sebastian" (1876)
Oil on wood,
67.8 x 38.7 cm
Fogg Art Museum,
Cambridge,
Massachusetts

wanted the picture to be interpreted as a fight between the physical and the spiritual, specifically with reference to the situation in France. In this painting he was warning about the consequences of the industrial revolution and the dechristianization of society, since the apparent triumph of modern science increasingly suppressed the divine mystery.

This curious passivity was also a characteristic of Moreau's other representations of angels. In the *Martyrdom of St. Sebastian* (see fig. p. 14), for example, he re-interpreted the incident in a psychological manner: an angel with powerful wings hovers beside the martyr's head. The divine messenger does not assist the saint physically, however; his arms are folded in front of his breast. It is only through the intensity of his gaze that he fills the suffering man with courage. A later watercolor (see fig. p. 72) shows an angel sitting on the tower of Notre-Dame. The angel looks tired; he is far removed from the bustle of modern life, gazing down on it from a distance. It is possible that this angel expressed a feeling of longing on the part of Moreau. His contemporary, Joris-Karl Huysmans, described him as a "mystic imprisoned in the heart of Paris, in a cell into which the noise of contemporary life no longer penetrates."[11]

This type of escapism from modern life was also a characteristic of the work of the Symbolist Odilon Redon. He too rejected contemporary materialism, whereby he equated the Earth with matter and sought goodness and beauty "in Heaven." It is only logical, therefore, that he regarded the angel as a figure who mediated between the opposite poles of spirit and matter. For Redon, Man himself is in some respects a fallen angel, who has lost the state of innocence through his desire for knowledge, through modern science as a consequence of the Enlightenment. Since he will never be able to know everything, he is susceptible to melancholy. Redon examined this "fallen angel," who can also be interpreted as a fallen man, in a number of drawings and paintings. Redon's angels are mostly pensive, melancholy failures, like Icarus, whom he also portrayed; he never shows them flying. Their over-sized wings are often so heavy that they appear to be completely unsuitable for flight, but rather keep the heavenly creatures on the ground. In the picture *Angel in Chains* (see fig. p. 60) Redon showed a female angel with black wings. The references to Dürer's *Melancholia* are obvious: like the latter, the angel sits on a rock, supporting its head with its hand. The angel cannot fly, since it is chained to the rock. It is painted in ocher like the rock itself, and so is tied to the rock visually as well as physically.

The pastel picture of *Jacob Wrestling with the Angel* (see fig. p. 16) dates from a later point in Redon's career. It is known that Redon was familiar

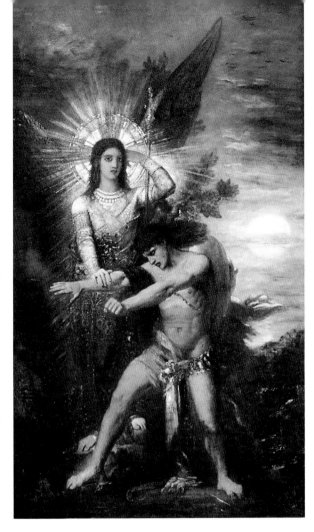

GUSTAVE MOREAU
"Jacob and the Angel"
(1878)
Oil on canvas,
255 x 147.5 cm
Fogg Art Museum,
Cambridge,
Massachusetts (Bequest
of Grenville L. Winthrop)

15

with the picture of Jacob's struggle created by Delacroix (see fig. p. 37). Even in the case of the latter painting, contemporary critics complained that the landscape occupied too much space compared with the scene of the fight.

Paul Gauguin presented the subject of Jacob wrestling in a very different way (see fig. pp. 76/77). The struggle itself is only indirectly a subject of the picture, as it takes place in the imagination of the Breton peasant women who are portrayed in the foreground of the picture. The branch of a tree divides the painting into two sections: that of the peasant women and that of the vision. Against a red background, the blue-robed angel with yellow wings wrestles with Jacob and seems to be clearly his superior.

Like the stylistic device of dividing up the picture surface by means of a branch, and thus breaking up the central perspective within the picture construction, the depiction of the struggle also harks back to the representation of fights in Japanese woodcuts, which were of enormous importance at the time for the development of French artists. This was particularly true of the artists' group Les Nabis, founded in 1888/89. Under the influence of Gauguin these "Prophets" developed a completely new pictorial language. The starting point was no longer an impression of nature, as it had been for the Impressionists, but rather the imagination, the contemplation of the essential idea. Apart from Japanese woodcuts, the artists used folk art and the paintings of Puvis de Chavannes as their models in the design of their pictures. Christian-religious subjects did not play a role for all the members of Les Nabis. Nonetheless, representations of angels can be found among the works of Paul Sérusier, Émile Bernard, Charles Filiger and others, especially Maurice Denis, the leading theoretician in the group.

For Denis, who was also known as the "Nabi of the beautiful icons," painting was "essentially a religious and Christian art form."[12] He aimed to express religious sentiment through forms and colors. In doing so he helped to bring about a renewal of French religious art during the twentieth century. For Denis, the essence of religious art lay in the "virginity" of the observation, in the undisguised, naïve perception and reproduction. Art, for him, was a creation of the spirit and not the slavish reproduction of nature which he accused the academies of propagating.

Although he was strongly influenced by the paintings of Gauguin, Denis nonetheless presented the subject of Jacob wrestling with the angel very differently (see fig. p. 90). He did not show a physical struggle, but interpreted it – as Moreau had done – as a psychological event, as the "visualization of inner conflicts."[13] The angel is shown as a "reflection" of Jacob, as his alter ego; it could stand for the resistance, the feelings of guilt and inconsistency in Jacob's biography, against which the latter is struggling during the night.

The way Denis presented the scene of the *Annunciation to the Virgin Mary (Catholic Mystery)* (see fig. p. 80) is completely novel: Denis replaced the

16

Archangel Gabriel by a deacon with a halo who carries the Gospels before him. He is assisted by two choirboys bearing candles who are also portrayed with haloes. Since the Middle Ages, angels had frequently been replaced by deacons as servants in the divine liturgy. Here, however, the officiant himself replaces the angel. Thus the deacon becomes the herald and in this "Catholic Mystery" the liturgy becomes the annunciation of God's Word, analogous to Gabriel's annunciation to the Virgin Mary. In the picture of the Virgin Mary and Mary Magdalene at the tomb, *Noli me tangere* (see fig. p. 19), Denis presented his own interpretation of a classical subject. He transfered the events of Easter morning to the familiar countryside near Saint-Germain-en-Laye, where he lived with his family. The foreground is occupied by two angels – without wings, as in early Christian art. Denis dispensed with details, such as the burial cave and the women's ointment vessels, in favor of the spiritual expression of the scene. The prophecy of Christ's resurrection is depicted through the gesture of the raised hands.

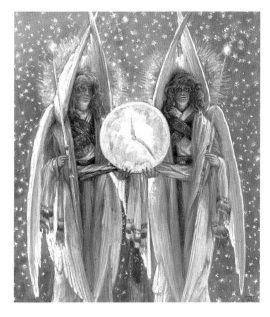

JAMES TISSOT
"Angels Holding a Dial Indicating the Different Hours of the Acts of the Passion"
From the series: *"The Life of Our Lord Jesus Christ"* *(1886–1894)*
Watercolor on paper, 19.7 x 17.1 cm
Brooklyn Museum, New York

James Tissot differed from the artists described so far by virtue of his historicist approach, which he linked with Symbolist imagery. In order to prepare for his Bible illustrations, he travelled to Palestine on several occasions, in order to study the local culture and reproduce it as accurately as possible. In 1894 he exhibited 350 gouaches in Paris for the first time under the title *La Vie de Notre Seigneur Jésus-Christ* (The Life of our Savior Jesus Christ); they were subsequently published in two volumes. Angels played an important role in the illustrations of the Biblical scenes, with Tissot developing a completely new, independent approach. Thus, in the scene in the Garden of Gethsemane (see fig. p. 74), he deviated completely from the Biblical text. Instead of showing an angel

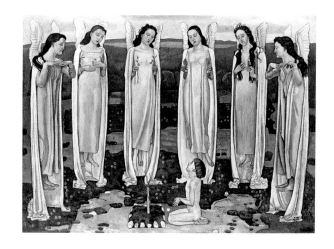

FERDINAND HODLER
"The Chosen One" (1893/1894)
Tempera and oil on canvas, 219 x 296 cm
Kunstmuseum Bern, on permanent loan from the Gottfried Keller foundation

giving encouragement to Christ in his mortal fear of the Crucifixion, he replaced the single angel with a group of angels forming a circle around Christ as he lies on the ground. They hold symbols of the Passion, including the Veil of Veronica and glass spheres on which the stations of the suffering to come are shown, such as the Crucifixion or the grieving Mother of Jesus.

Other pictures portrayed angels holding a clock face (see fig. p. 17 above) depicting the hours of the Passion. The angels are clad in elaborate priest's vestments with the stola crossed in front of their breasts, thereby linking them with the tradition of showing angels as priests or ministrants. This concept, which had existed since earliest Christian times, thus distinguished them as servants in the liturgy both in Heaven and on Earth. The angels are also shown bearing staffs of light, confirming them as bringers of light against the dark starry firmament. Like many of Tissot's angelic figures, they are shown as Cherubim with three pairs of wings. Tissot's representations thus combine various currents of the late nineteenth century: a mystic Catholicism, spiritist-occult ideas, and a historicist positivism.

There was a lively exchange of ideas between French and Belgian Symbolist artists, which was encouraged in particular by the Belgian Société des Vingt (Les XX). Works by artists including Denis, Segantini, Whistler, Klinger, and Bernard were presented in their exhibitions. The group La Libre Esthétique showed works by Watts, Hunt, Gauguin, Denis, Ranson, Redon, Munch and others in their exhibitions. The latter association was influenced by the Belgian Symbolist writer Maurice Maeterlinck. Antoine Wiertz was one of the forerunners of Belgian Symbolism. His works linked Baroque pathos with the sublime and the sinister.

Artists such as Jean Delville, Léon Frédéric, and James Ensor also focused on Christian pictorial subjects. Ensor interpreted the events leading to the expulsion of Adam and Eve from Paradise as a "light event," employing a painting style which was remarkably free and gestural for the time. Ensor certainly knew J. M. W. Turner's painting of *The Angel Standing in the Sun* (see fig. p. 41), in which there was also a close connection between the angel and the sun. Turner's portrayal of the angel as a shining light is so intense, however, that its appearance is almost dissolved in the light.

Even more expressive as regards brushwork and color scheme is Ensor's *Fall of the Rebel Angels* (see fig. pp. 82/83), a subject which inspired the artist to dramatic scenes on a number of occasions (cf. fig. p. 92). The fall of the rebel angels dissolves into a painting style which can almost be called actionistic. The individual angels can scarcely be distinguished from each other in the red and brown brushstrokes; only their long lances are recognizable.

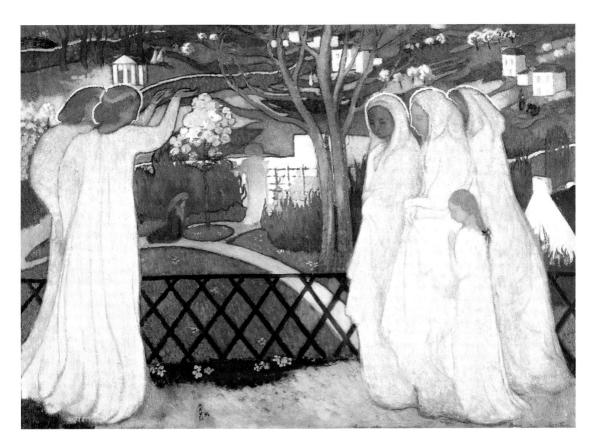

SYMBOLISM IN EUROPE

MAURICE DENIS
*"The Women at the Tomb.
Noli me tangere" (1894)*
Oil on canvas,
74 x 100 cm
Musée départemental
Maurice Denis, Saint-
Germain-en-Laye

The Italian artist Gaetano Previati was also concerned with the reproduction of light. In his works he combined Divisionism with Symbolist pictorial ideas, whereby the shimmering light served to convey the spiritualization of painting and not the portrayal of an optical impression. In his painting *Motherhood* (see fig. pp. 88/89) he showed a mother carrying a small child and surrounded by a host of angels. The angels elevate the subject of motherhood into the realm of Christianity, which in any case bears echoes of the Mother of God with the Christ Child. They recall the representations of guardian angels, which were popular at the time. At the Triennale in Brera in 1891, the picture provoked a scandal because of its shapeless painting style and its mysticism. Nonetheless, Previati was able to present it on a second occasion, at the *Salon de la Rose+Croix* in Paris. Previati was influenced by the works of the English Pre-Raphaelites, as was Giovanni Segantini, an artist from Tyrol. The latter developed a painting style which combined Pointillist technique with Symbolist content. The starting point was always the observation of nature, and especially of the landscapes of Engadin, where Segantini lived. The wonderful landscape around Maloja is portrayed in the picture *Love at*

19

the Fountain of Life (see fig. pp. 102/103). In a letter, Segantini wrote of this picture: "An angel, a mystic, suspicious angel spreads its broad wings over the mysterious fountain of life. The spring water flows out of the living rock, both symbols of eternity."[14] The angel is not a traditional Christian angel, but represents Spring, Fertility, Love, and Nature, in line with Segantini's pantheistic piety devoted to Nature and the divine origins of life.

At about the same time as Segantini, the Swiss artist Ferdinand Hodler began to paint Symbolist pictures. He depicted angels as the symbol of the life force of Nature. In *The Chosen One* (see fig. p. 17 below) six female angels, whose blue robes recall portraits of the Virgin Mary, are lined up around a boy in the manner of guardian angels. The boy kneels before a freshly planted sapling. Together with the angels, which hold young plants in their hands, he symbolizes the powers of nature, of spring and of creation.

Carlos Schwabe, who lived in Geneva and France, maintained contact with the group of Rosicrucians in Paris, like Hodler; he also designed the poster for their first exhibition. Schwabe was in close contact with writers like Zola, Maeterlinck, Baudelaire and Mallarmé, whose books he illustrated. In the picture *The Death of the Grave-Digger* (see fig. p. 95), Schwabe showed a grave-digger who is visited by an Angel of Death while working in a snow-covered cemetery. The grave the man digs thereby seems to become his own.

In Germany, where Symbolism was never strongly represented, it was above all the artist Franz von Stuck in Munich who advocated the new Symbolist approach to art. Von Stuck rebelled against the conservative artistic policies of Luitpold, the Prince Regent of Bavaria. He was one of the co-founders of the Munich Secession, which showed works by Symbolist artists like Schwabe, Aman-Jean, Crane, and Segantini at their first exhibition in 1893, as well as Burne-Jones, Rossetti, and Hodler in 1897.

Even before the founding of the Secession, Stuck demonstrated his new approach to art with the much-admired painting *The Guardian of Paradise* (see fig. p. 84). The angel who guards the gateway to Paradise in order to prevent those who have been expelled from ever returning, is shown here as a self-assured Hellenic youth. The angel appears as a bright shining light, and the space surrounding the figure glows in bright pastel colors. This magnificent blaze of color is applied in Impressionist style and forms the true "Paradise." It is painting – and especially modern open-air painting – which the angel defends. He therefore becomes the artist's alter ego, which is how the angel was interpreted immediately after this early work was exhibited. Thus the critic Julius Bierbaum described the picture as "a painted 'here I am'!"[15] Painted a year later, the fallen angel Lucifer appears to be a "diabolical opposite"[16] (see fig. p. 87), as he sits in the "thinker" pose and gazes at the viewer out of fiery eyes.

In the Scandinavian countries, Symbolism was to be found predominantly in landscape painting. The Finnish artist Hugo Simberg was the exception in this respect; inspired by the literary Symbolism of France and role models like Gauguin, Puvis de Chavannes and Böcklin, he developed an individual and mysteriously Symbolist pictorial language. His most famous painting was *The Wounded Angel* (see fig. p. 21

above), which showed an angel in the form of a winged, injured girl being carried on a stretcher by two youths. The picture should be viewed in the light of the fact that Simberg fell seriously ill with meningitis, though he subsequently recovered. The landscape in the picture resembles the surroundings of the hospital in Helsinki, in which he spent six months as a patient. Perhaps the angel represents the artist or the artist's soul and at the same time his ability to overcome the illness.

The artists who were members of Young Poland represented the spirit of change within that country. They responded to French Symbolism and soon established contact with cities like Paris, London, Berlin, and Munich, where they were able to present their works. Politics played a more important role for the representatives of a country which was involved in a constant struggle to assert its identity than it did for other European artists. The landscape often stood for the concept of "homeland," as in the works of Jacek Malczewski. Thus the expansive, surreal-looking landscape dominated the picture *Spring – Landscape with Tobias* (see fig. p. 108). It is traversed by a deep ditch along which the youth Tobias strides, accompanied by his guardian angel Raphael. From the Old-Testament story in the Book of Tobit, which became the model for guardian angels, Malczewski shows the moment when Tobias returns from his journey, on which he was accompanied by Raphael. In his hands Tobias carries the fish whose entrails he will use to cure his father's blindness. Together with the spring landscape, Tobias and the angel thus become symbols of light and hope.

The works of the Lithuanian artist Mikalojus Konstantinas Čiurlionis were painted entirely in Impressionistic pastel shades. He was also influenced by more contemporary artists like Klee, Kupka, and Kandinsky. Čiurlionis visualized Paradise (see fig. pp. 112/113) as an idealized whole, consisting of a landscape beside the sea and an atrium-like architecture of stairs upon which a host of angels strolls and picks flowers.

The angelic visions of the Russian artist Mikhail Wrubel, on the other hand, were marked by the somber mood of the fin de siècle. In one of his principal late works, the *Six-Winged Seraph* (see fig. p. 111), the angel approaches the viewer as an auspicious and at the same time menacing-looking figure. The model for the female divine messenger was Wrubel's wife, Nadezhda Zabela. The picture was designed like a shimmering mosaic

HUGO SIMBERG
"The Wounded Angel" (1903)
Oil on canvas, 127 x 154 cm
Finnish National Gallery,
Ateneum Art Museum,
Helsinki

FATHER GABRIEL (JAKOB) WÜRGER, FATHER LUCAS (FRIDOLIN) STEINER
"Ten Angelic Figures, Standing" (1874)
Oil on canvas, cut out and mounted individually,
c. 167 x 55 cm each
Erzabtei St. Martin, Beuron

of purple and yellow tones. The seraph holds a snake, a sword and a censer. These attributes can be explained by Pushkin's poem *The Prophet* (cf. p. 110), to which the painting and a watercolor with the same title refer (see fig. p. 110). Pushkin described the process of the inspiration of a prophet by a seraph. This is effected in a brutal manner: the seraph rips the prophet's tongue out of his mouth and replaces it with the sting of the wise snake. Thereupon the angel cuts the wise man's heart out of his chest using a sword and replaces it with glowing coals. Wrubel identified himself with the prophet, while the similarity between the seraph and his wife referred to her role as his muse.

PARALLEL MOVEMENTS TO SYMBOLISM AND ITS SPHERE OF INFLUENCE

Parallel to Symbolism, artists who worked in a more traditionally academic style, like the French painter William Bouguereau, also created numerous representations of angels (see fig. p. 106). They were often intended to decorate churches. Other artists of the time were also intent upon finding a new way of portraying Christian themes, including for example, the representatives of the Beuron School. Exposed to Egyptian and Byzantine art, the painters of the Beuron School created an abstract, stylized language of forms which manifested itself primarily in wall paintings. Many of these works were characterized by a severely symmetrical, hieratic-looking composition. An example can be seen in the standing angels (see fig. p. 21 below) created for the choir of the monastery church at Beuron. The artist Jan Verkade provided the principal link between the French Symbolists and Beuron, as he was in close contact with Les Nabis in France and entered the Benedictine abbey of Beuron in 1894. He was the director of their art school at one point.

Jugendstil and Art Nouveau were directly influenced by the Arts and Crafts movement of William Morris. One of the main representatives of this new artistic approach, the Belgian painter Henry van de Velde, created the appliqué work *Angels' Watch* (see fig. below). Its curved forms were clearly inspired by Maurice Denis. The work, which shows heavenly creatures without wings, echoes the pictures of guardian angels, as well as portraits of the newborn infant Jesus being watched over by angels. The influence of the Arts and Crafts movement extended as far as America, where Louis Comfort Tiffany founded one of the most important interior design stores of the time in New York. His fame rested in particular on his development of the technique of making iridescent glass. Tiffany's Art Nouveau creations included numerous stained-glass windows and mosaics for churches (see fig. p. 115), often with impressive representations of angels.

HENRY VAN DE VELDE
"The Angels Watch"
(1893)
Appliqué, wool and silk,
140 x 233 cm
Museum für Gestaltung
Zürich, Zurich

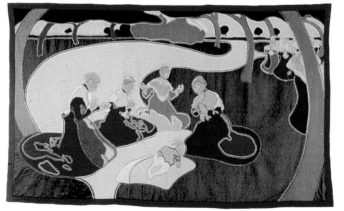

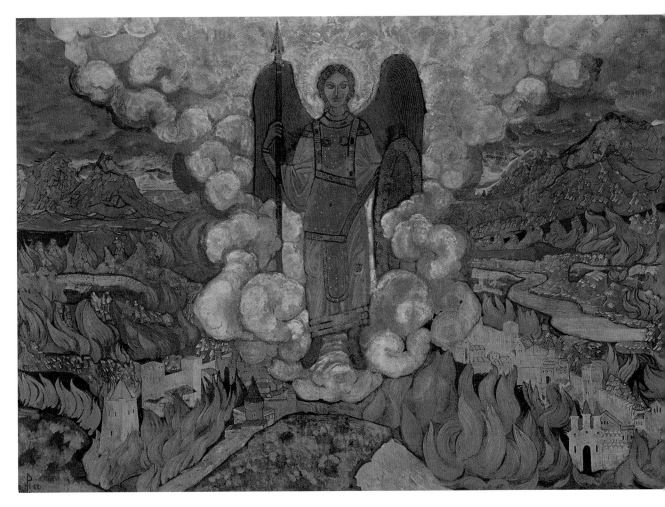

The Austrian artist Koloman Moser, one of the co-founders of the Wiener Werkstätte (Vienna Workshop), created stained-glass windows for one of the most important Jugendstil churches, the Kirche am Steinhof in Vienna, constructed by Otto Wagner between 1904–1907 (see fig. p. 114). The figures of angels here are more strongly stylized and geometrical in form than those of Tiffany.

Through its free treatment of traditional iconography and its subjective, often emotional interpretation of the figures of angels, Symbolism paved the way for completely new angel figures during the twentieth century. The early works of Wassily Kandinsky were created against the background of his close contact with the Russian Symbolists, like Nicolai Roerich (see fig. above) and Wrubel, as well as the Jugendstil movement in Munich. Referencing folk art techniques like reverse-glass painting, Kandinsky took up traditional Christian pictorial subjects such as All Saints (see fig. p. 24) and the Archangel Gabriel (see fig. p. 117). Like the Symbolists, he was concerned with expressing the "spiritual" in color and form, as can be seen in his free compositions and strong colors.

NICHOLAS ROERICH
"The Last Angel" (1912)
Tempera on cardboard,
52 x 73.6 cm
Nicholas Roerich
Museum, New York

23

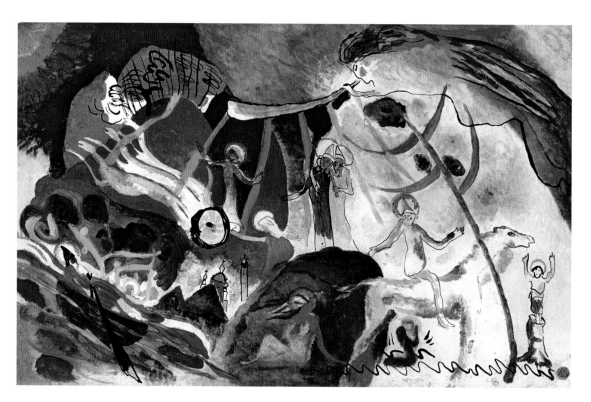

WASSILY KANDINSKY
"All Saints II" (1911)
Reverse glass painting,
31.1 x 47.8 cm
Städtische Galerie im
Lenbachhaus, Munich

In the picture *All Saints II* (fig. above) an angel approaching from the top left hovers with a trumpet which identifies him as the Angel of the Last Judgment. Beneath the angel can be seen a turbulent, eschatological scene composed of various saints, a Russian town, and a rowing boat on the left-hand side.

Surrealism, with its ambiguous imagery and the dream as a picture source, follows directly in the tradition of its Symbolist predecessors. Angels also occupied a central position in Salvador Dalí's work and thought. He is said to have observed to a Dominican priest: "… nothing excites me more than the idea of an angel." In one painting he shows his wife Gala as an angel in their home town of Port Lligat (see fig. pp. 122/123).

For Paul Klee, who was a pupil of Franz von Stuck among other things, the angel became the cipher for the invisible world which is to be made visible through art. Like the Symbolists he sought a "pristine," authentic world and found it in the drawings of children. Often his pictures of angels, reduced to a handful of lines, are in the process of becoming; in the *Archangel* (see fig. p. 120) this task must be carried out by the viewers themselves. The *Angelus descendens* (see fig. p. 119) on the other hand stands for the angel as messenger and – together with the dove of the Holy Ghost – for the process of artistic inspiration.

The twentieth-century artist who most frequently portrayed angels was Marc Chagall. In all religious works by the artist, whose oeuvre was deeply rooted in Jewish culture, angels were the "most frequently used pictorial symbol." By means of the angel, Chagall expressed the

24

idea that the world of the here-and-now and the world of the hereafter were "permeable to each other."[17] He repeatedly found new images for traditional themes, such as the *Creation of Man* (see fig. p. 124). Instead of showing God the Creator, an image which he as a Jew was not permitted to represent, Chagall depicted an angel carrying Man, still rather lifeless-looking, into God's Creation. As he looks back, he is perhaps gazing towards the Creator from whom he has come. This representation does not correspond with the Biblical report of the Creation; it may therefore be based instead on an apocryphal legend which was widespread throughout Judaism in general and which related that the Archangel Michael carried Adam, whom God had formed from a clod of clay, up to heaven. There the angels were to worship him as the only being created in the image of the Most High. The painting shows the moment in which the Archangel Michael carries Adam back down to Earth.

The pictures of Marc Chagall and Paul Klee in particular are all-pervasive and demonstrate how well angels have survived into the twentieth century. In spite – or perhaps because of – continuing secularization, angels continue to enjoy increasing popularity in art. To this day, artists like Jeff Koons and Anselm Kiefer continue to study the subject, which developed during the nineteenth century, and represents an essential precondition for their new works.

1　Herbert Vorgrimler, Ursula Bernauer, Thomas Sternberg, *Engel. Erfahrungen göttlicher Nähe*, Freiburg, Basel, Vienna 2008, p. 21.

2　Karl August von Hase, quoted in Heinrich Krauss, *Die Engel. Überlieferung, Gestaltung, Deutung*, Munich 2005, p. 90.

3　Friedmar Apel, *Himmelssehnsucht. Die Sichtbarkeit der Engel in der romantischen Literatur und Kunst*, Paderborn 1994, p. 23.

4　Apel, (see note 3), p. 11.

5　Max Osborn, *Der bunte Spiegel. Erinnerungen aus dem Kunst-, Kultur-, und Geistesleben der Jahre 1890 bis 1933*, New York 1945, p. 18 ff., quoted in: Gisela Götte, *Lust zur Erkenntnis, Lust zu Gott. Gnostische Geheimlehren und christliches Weltbild in der bildenden Kunst des Fin de siècle*, in: exh. cat. *Symbolismus und die Kunst der Gegenwart*, Wuppertal 2007, pp. 73–84, p. 73.

6　Jean Moréas, *Le Symbolisme*, first published in: *Figaro littéraire*, 18.9.1886, reprinted in German translation in: Hans H. Hofstätter, *Symbolismus und Kunst der Jahrhundertwende*, Cologne 1965, pp. 227–229, p. 228.

7　Quoted in: Nadja Putzert, *'Where have all the Flowers Gone?' Buchkunst und Kunstbuch am Beispiel des* Flower Book, in: Edward Burne-Jones, *Flower Book*, Gabriele Uerscheln (ed.), Stiftung Schloss und Park Benrath, Munich 2010, pp. 110–119, p. 118.

8　William Morris quoted in: exh. cat. *Präraffaeliten*, Baden-Baden 1973, p. 163.

9　Christofer Conrad, "Die Suche nach dem Heiligen Gral und religiöse Themen", in: exh. cat. *Edward Burne-Jones. Das Irdische Paradies*, Stuttgart 2009, pp. 156–177, p. 160.

10　Günter Metken, "Die zornigen Viktorianer", in: exh. cat. *Präraffaeliten*, Baden-Baden 1973, pp. 9–12, p. 11.

11　Pierre-Louis Mathieu (ed.), *L´assembleur de rêves. Écrits complets de Gustave Moreau*, Fontfroide 1984, p. 33 (Translated by the author).

12　"La peinture est un art essentiellement religieux et chrétien", Maurice Denis, quoted in: Jean-Paul Bouillon, *Die Situation um Denis*, in: exh. cat. *Maurice Denis 1870–1943*, Lyon et al. 1994/95, pp. 13–22, p. 13.

13　Exh. cat. *Maurice Denis* (see note 12), p. 152.

14　Giovanni Segantini, quoted in: exh. cat. *Giovanni Segantini 1858–1899*, Zurich 1990/91, p. 184.

15　Otto Julius Bierbaum, *Stuck*, Bielefeld/Leipzig 1899, p. 30, quoted in: Thomas Raff (ed.), *Christliche Themen im Werk Franz von Stucks*, Tettenweis 2005, p. 13.

16　Ibid. p. 18.

17　Christoph Goldmann, *Bild-Zeichen bei Marc Chagall*, Göttingen 1995, vol. 1, p. 24.

And with the morn those
Angel faces smile,
Which I have loved long since,
And lost a while.

JOHN HENRY NEWMAN

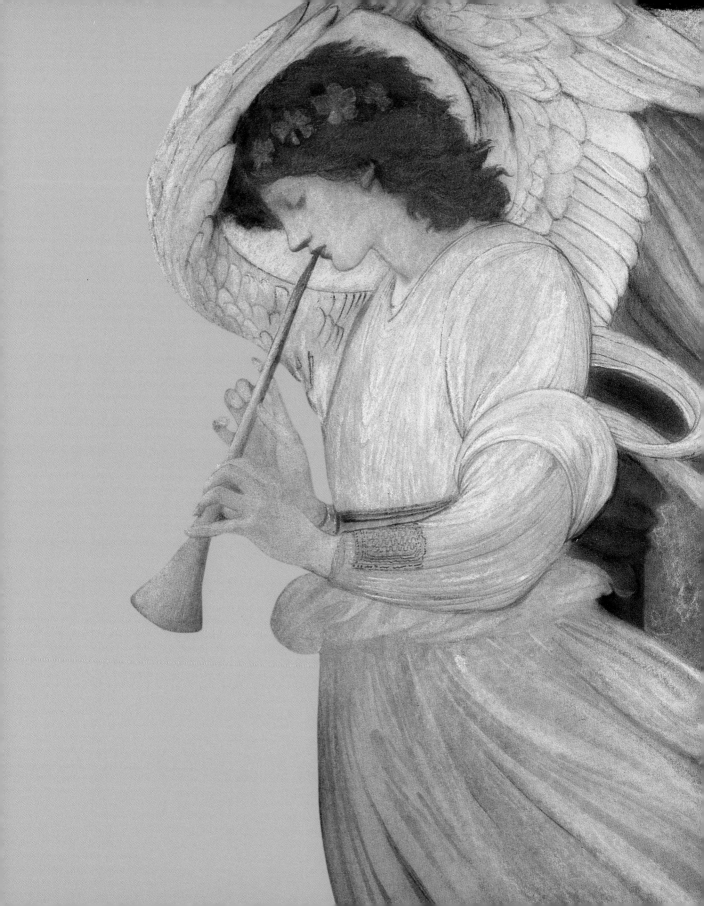

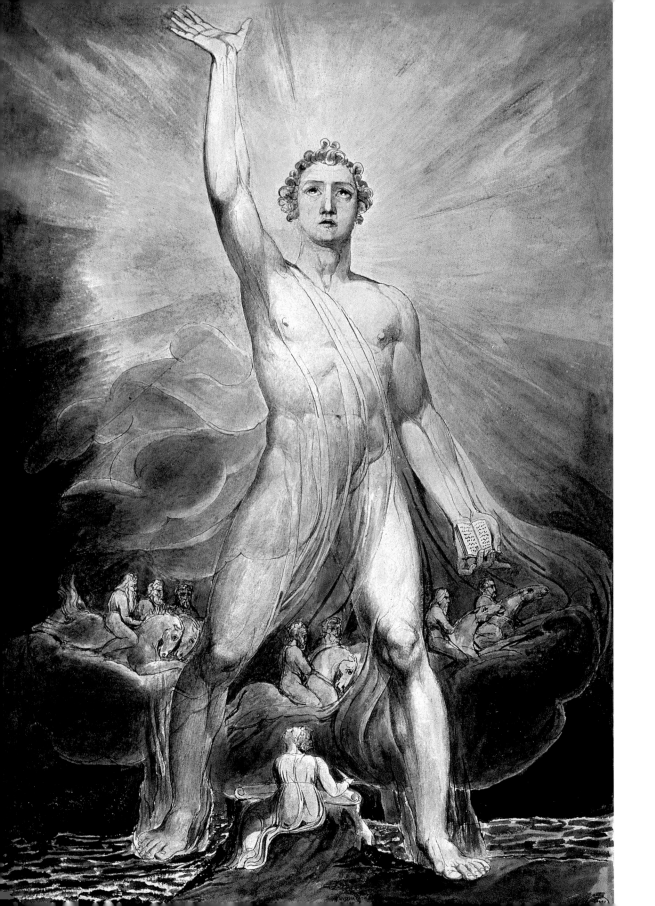

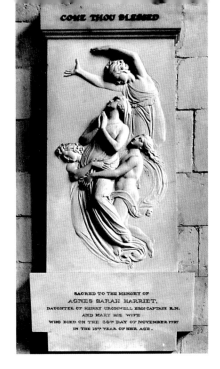

"And I saw another mighty angel come down from heaven, clothed with a cloud: and a rainbow was upon his head, and his face was as it were the sun, and his feet as pillars of fire: and he had in his hand a little book open: and he set his right foot upon the sea, and his left foot on the earth, and cried with a loud voice, as when a lion roareth."

Revelation 10, 1–3

WILLIAM BLAKE
"Angel of the Revelation" (*c. 1803–1805*)
Watercolor, 39.3 x 26.2 cm
The Metropolitan Museum of Art, New York
A small depiction of John, the chronicler of the Apocalypse, is painted seated in the lower section of the painting. A monumental angel, whom he sees as part of his vision, stands over him.

JOHN FLAXMAN
"Monument to Agnes Cromwell" (*1797–1800*)
Marble
Chichester Cathedral, England
In classical antiquity, people already believed that after death the human soul was guided to the afterlife by angels. Here, angels without wings carry the soul of the deceased to God.

"His aspect to the powers supernal
Gives strength, though fathom him none may;
Transcending thought, the works eternal
Are fair as on the primal day."

JOHANN WOLFGANG VON GOETHE | *"Faust"*

PHILIPP OTTO RUNGE
"Morning" (*1808*)
Oil on canvas, 109 x 85.5 cm
Hamburger Kunsthalle, Hamburg

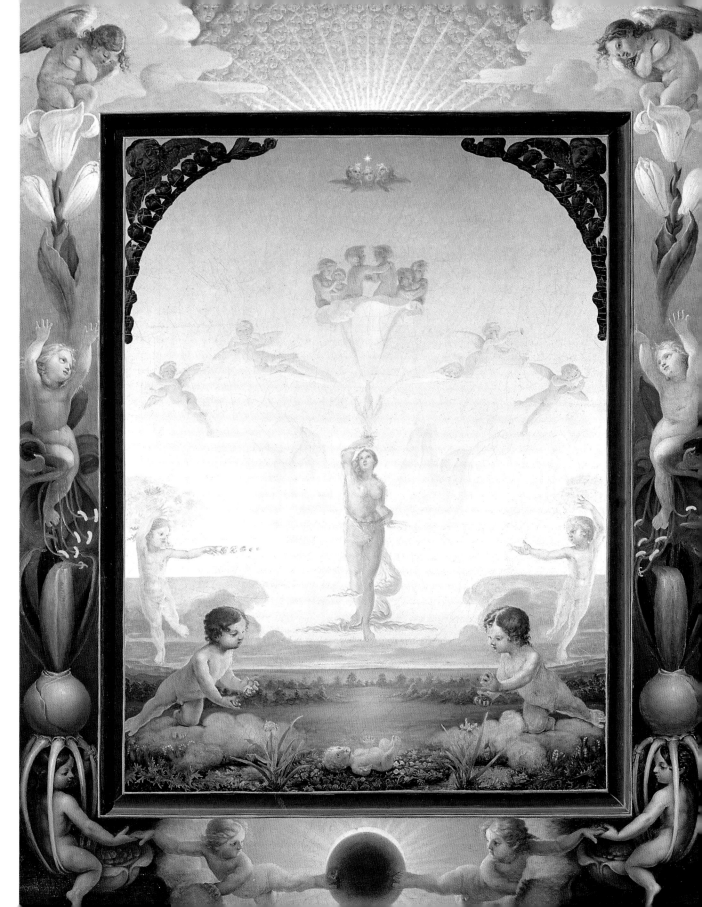

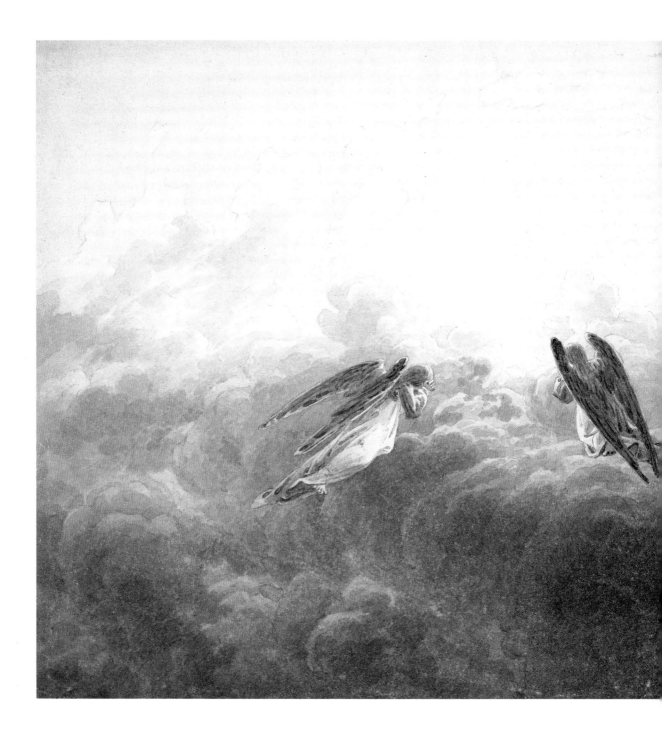

CASPAR DAVID FRIEDRICH
"Angels Floating Among Clouds" (*c. 1810–1820*)
Pencil and sepia, 18.5 x 26.7 cm
Hamburger Kunsthalle, Hamburg
Two angels, probably the souls of a deceased married couple,
float adoringly above the clouds.

The Angels

To be sure, a doubting Thomas,
I do not believe in them –
In the heavens clerics promise
Via Rome or Jerusalem.

But that angels are for real,
This I've never held in doubt;
Radiant creatures, pure, ideal,
Here on earth they walk about.

Sporting wings, you think? Now, duly
This, dear lady, I deny.
There are wingless angels truly –
I have seen them, even I.

Lovingly their white hands tend us,
Lovingly their visage glows
As they cherish and defend us,
Warding off misfortune's blows.

Great their favor! And to know it
Comforts all, but most indeed
Him whom people call a poet
And whose wounds still doubly bleed.

HEINRICH HEINE

33

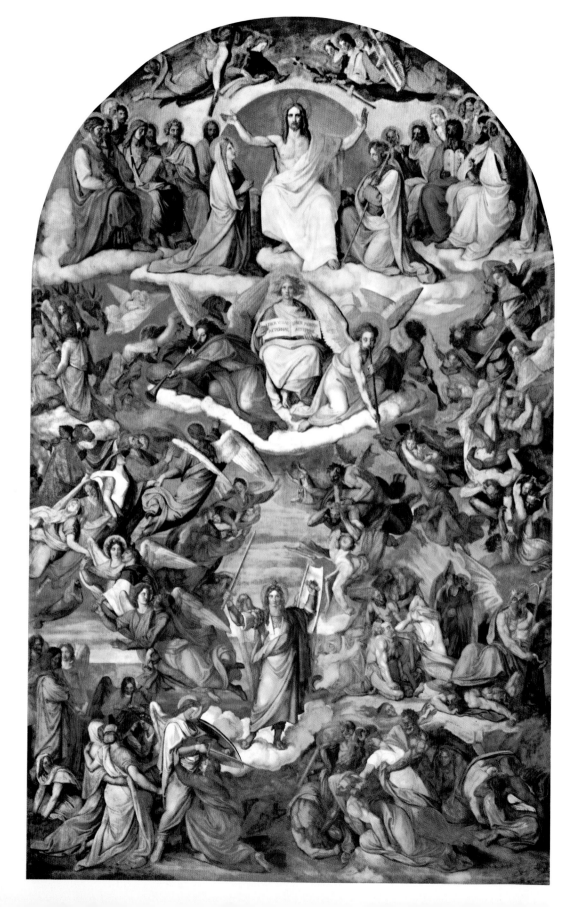

The Vision of Judgment

Saint Peter sat by the celestial gate:
His keys were rusty, and the lock was dull,
So little trouble had been given of late;
Not that the place by any means was full,

…

The angels all were singing out of tune,
And hoarse with having little else to do,
Excepting to wind up the sun and moon,
Or curb a runaway young star or two,
Or wild colt of a comet, which too soon
Broke out of bounds o'er th' ethereal blue,
Splitting some planet with its playful tail,
As boats are sometimes by a wanton whale.

The guardian seraphs had retired on high,
Finding their charges past all care below;
Terrestrial business fill'd nought in the sky
Save the recording angel's black bureau;
Who found, indeed, the facts to multiply
With such rapidity of vice and woe,
That he had stripp'd off both his wings in quills,
And yet was in arrear of human ills.

…

GEORGE GORDON | *"Lord Byron"*

PETER VON CORNELIUS
"The Last Judgment" (1836/1840)
Fresco
St. Ludwig, Munich

"Jacob set out with the flocks and gifts, with whose help he hoped to assuage the wrath of his brother Esau. A stranger appeared and barred his path and began to wrestle with him, which only ended when Jacob found himself completely powerless, having been touched by his adversary on the hollow of his thigh. The Holy Scriptures show this struggle as a symbol of the trials which God sometimes sends to his chosen ones."

EUGÈNE DELACROIX | *1861*

EUGÈNE DELACROIX
"Jacob Wrestling with the Angel"
Study for the painting in Saint-Sulpice
church in Paris
(c. 1838)
Oil on canvas, 45.5 x 29.8 cm
Narodni Galerie, Prague

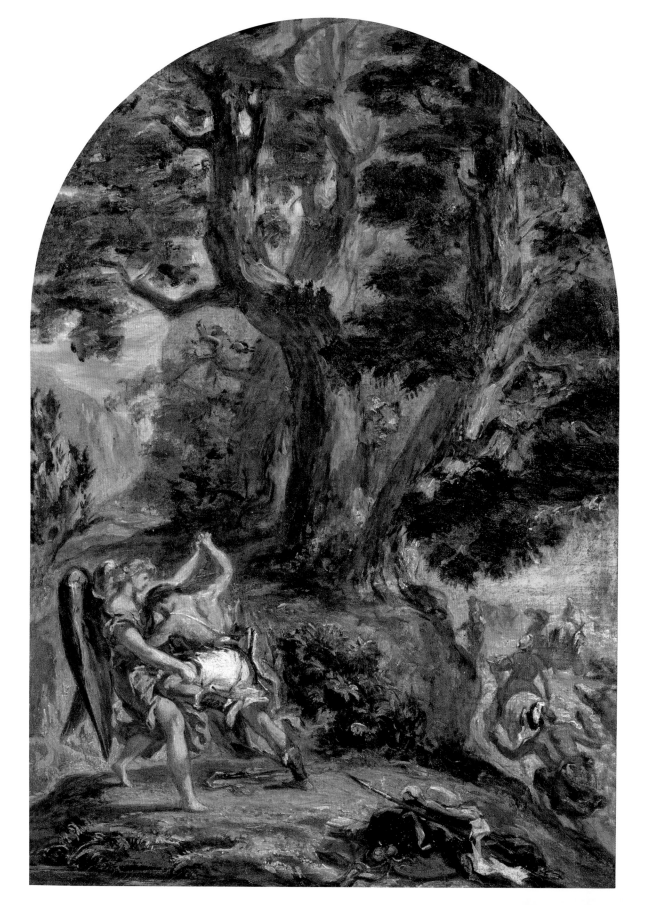

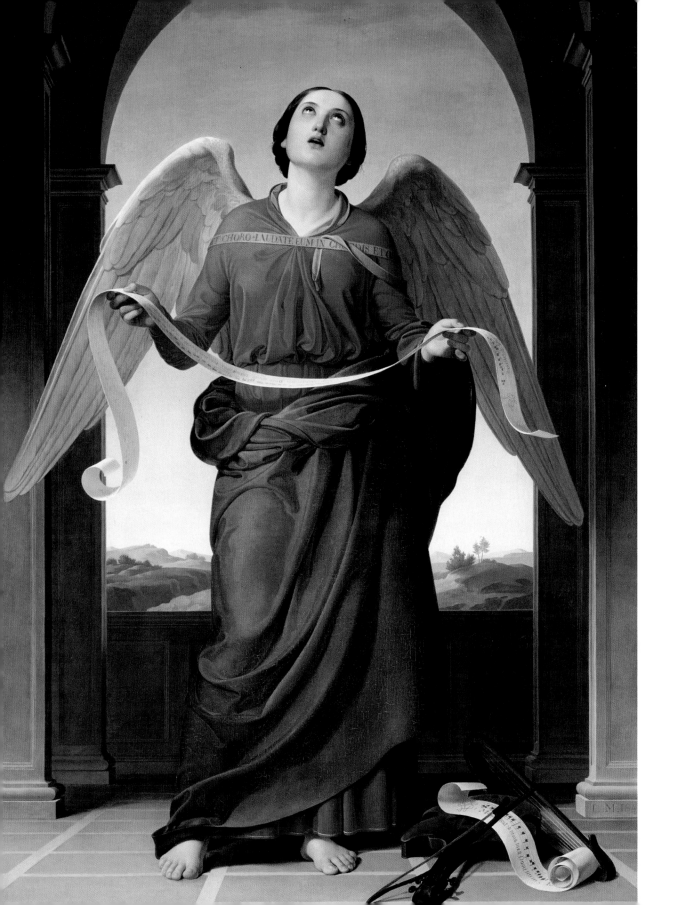

I Heard an Angel Singing

I heard an Angel singing
When the day was springing:
'Mercy, Pity, Peace
Is the world's release.'

Thus he sang all day
Over the new-mown hay,
Till the sun went down,
And haycocks lookèd brown.

. . .

WILLIAM BLAKE

LUIGI MUSSINI
"Musica Sacra" (1841)
Oil on canvas, 150 x 104 cm
Galleria dell'Accademia, Florence

"And I saw an angel standing in the sun; and he cried with a loud voice, saying to all the fowls that fly in the midst of heaven, Come and gather yourselves together unto the supper of the great God; that ye may eat the flesh of kings, and the flesh of captains, and the flesh of mighty men, and the flesh of horses, and of them that sit on them, and the flesh of all men, both free and bond, both small and great."

Revelation 19, 17–18

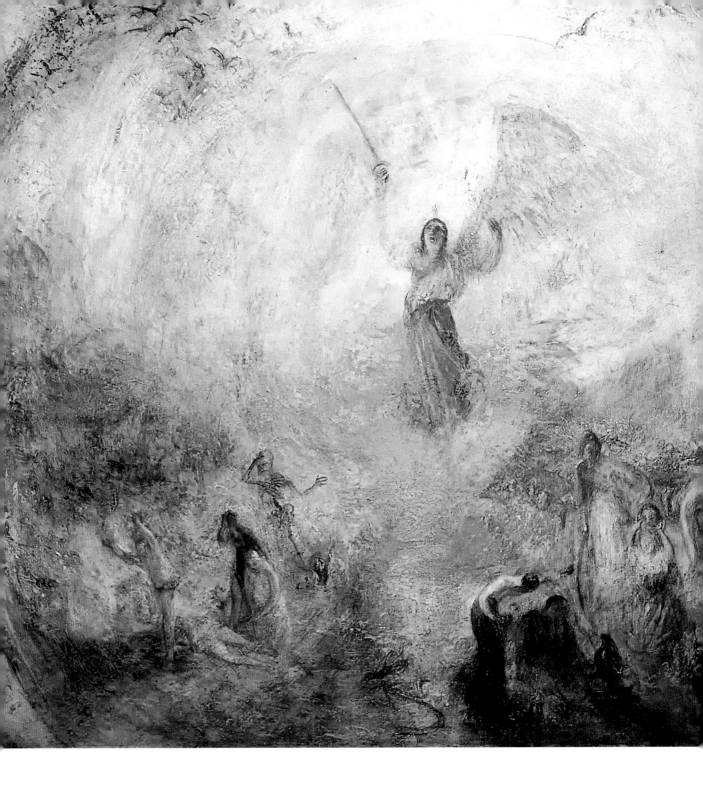

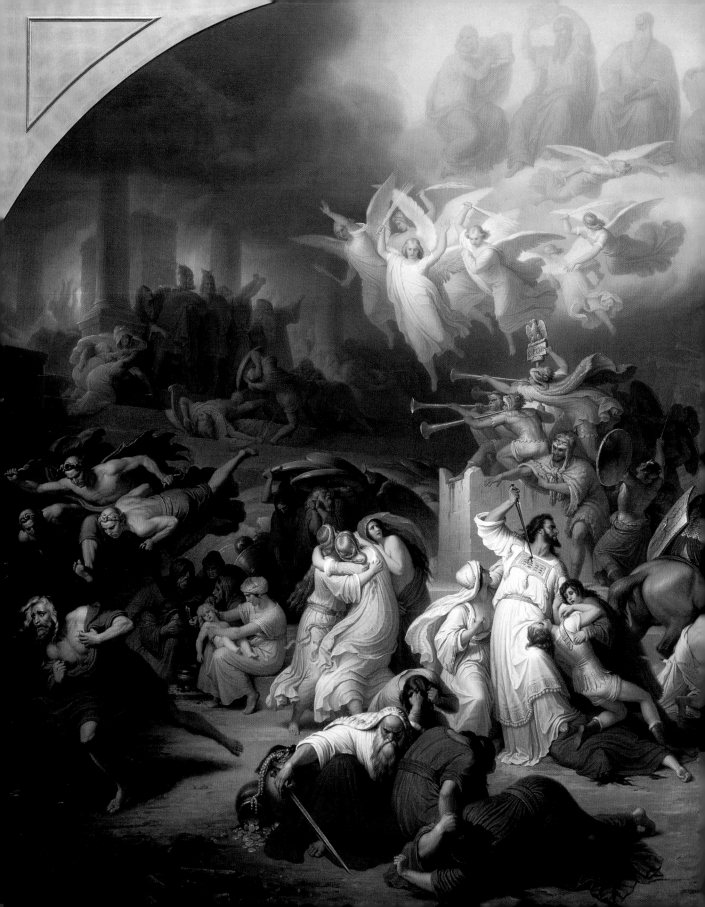

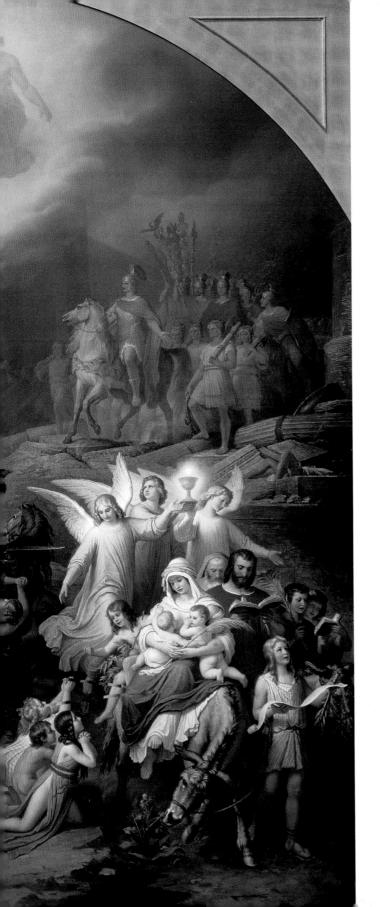

WILHELM VON KAULBACH
"The Destruction of Jerusalem by Titus" (1846)
Oil on canvas, 585 x 705 cm
Bayerische Staatsgemälde-
sammlungen, Neue Pinakothek,
Munich

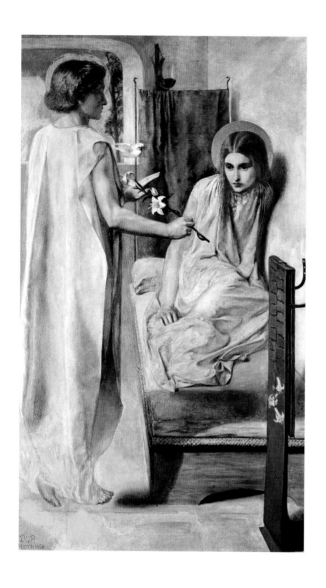

DANTE GABRIEL ROSSETTI
"Ecce Ancilla Domini!" (*1849–1850*)
Oil on canvas, 72.4 x 41.9 cm
Tate Britain, London

ARTHUR HUGHES
"The Annunciation" (*1858*)
Oil on canvas, 61.3 x 35.9 cm
Birmingham Museums and Art Gallery,
Birmingham

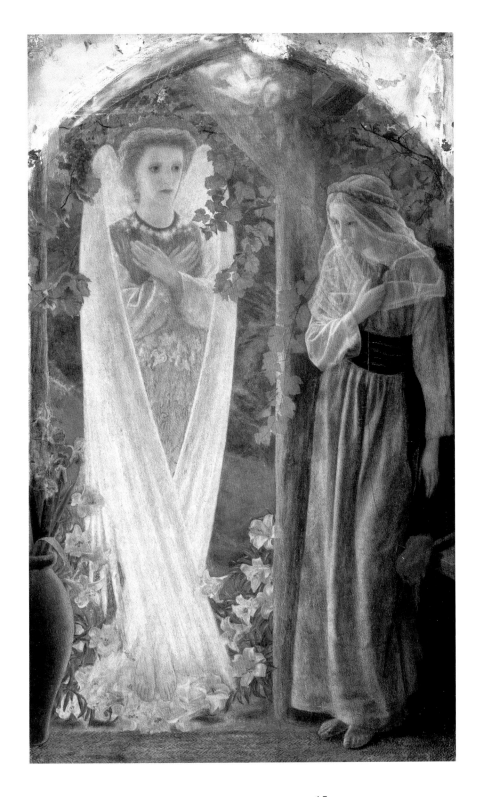

"Then lifting up mine eyes as the tears came,
I saw the Angels, like a rain of manna,
In a long flight flying back Heavenward;
Having a little cloud in front of them,
After the which they went and said 'Hosanna!'
And if they had said more, you should have heard.
Then Love spoke thus: 'Now shall all things be made clear:
Come and behold our Lady where she lies.'
These idle phantasies
Then carried me to see my lady dead:
And standing at her head
Her ladies put a white veil over her:
And with her was such very humbleness
That she appeared to say 'I am at peace.'

DANTE ALIGHIERI | *"Vita Nuova" in the translation by Dante Gabriel Rossetti*

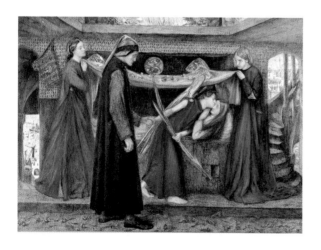

DANTE GABRIEL ROSSETTI
"Dante's Dream at the Time of the
Death of Beatrice" (1856)
Watercolor, 48.7 x 66.2 cm
Tate Britain, London

DANTE GABRIEL ROSSETTI
"Dantis Amor" (1859–1860)
Oil on mahogany panel, 74.9 x 81.3 cm
Tate Britain, London

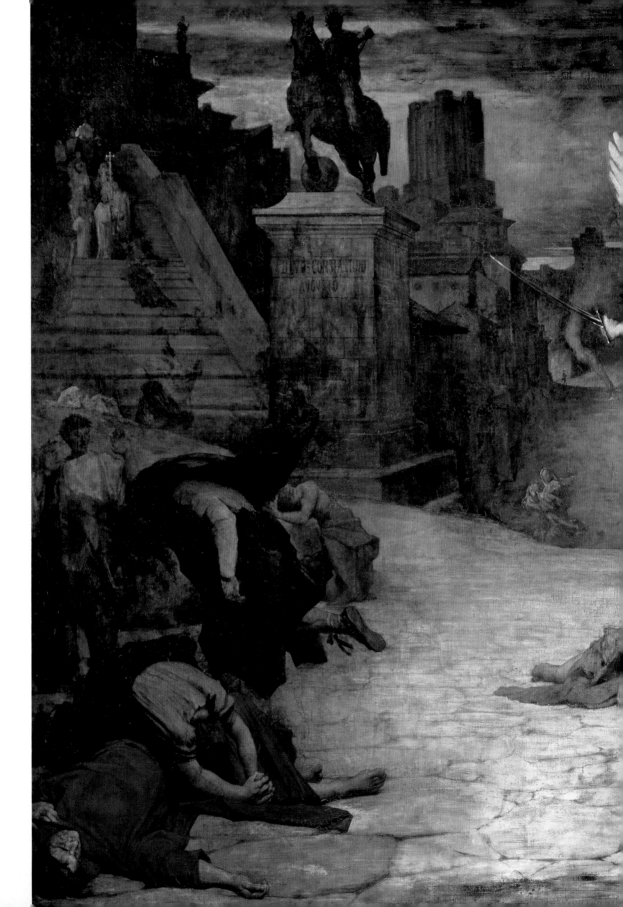

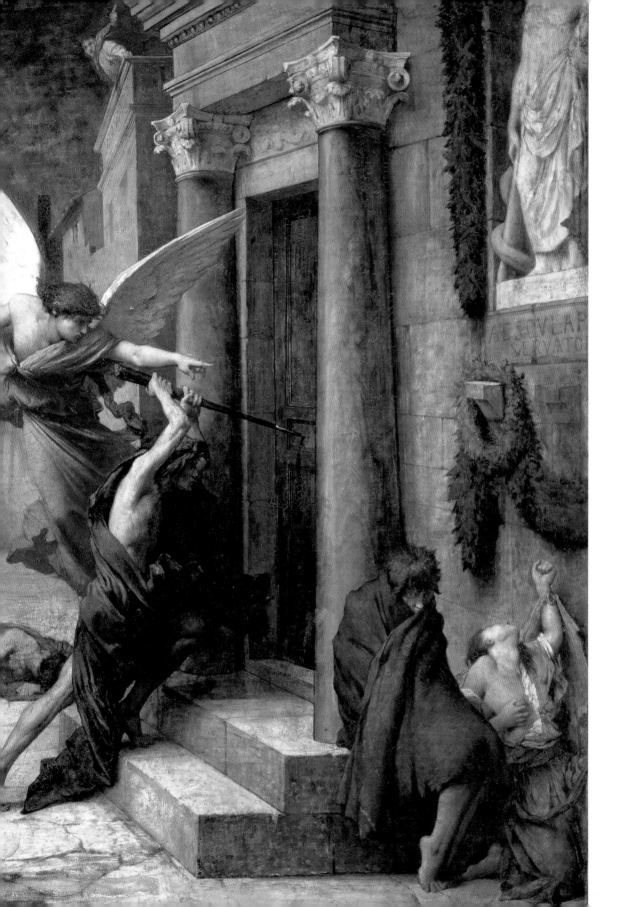

The Fallen Star

A star is gone! A star is gone!
There is a blank in Heaven;
One of the cherub choir has done
His airy course this even.

He sat upon the orb of fire
That hung for ages there,
And lent his music to the choir
That haunts the nightly air.

But when his thousand years are pass'd,
With a cherubic sigh
He vanish'd with his car at last,
For even cherubs die!

Hear how his angel-brothers mourn –
The minstrels of the spheres –
Each chiming sadly in his turn
And dropping splendid tears.

The planetary sisters all
Join in the fatal song,
And weep this hapless brother's fall,
Who sang with them so long.

But deepest of the choral band
The Lunar Spirit sings,
And with a bass-according hand
Sweeps all her sullen strings.

From the deep chambers of the dome
Where sleepless Uriel lies,
His rude harmonic thunders come
Mingled with mighty sighs.

The thousand car-borne cherubim,
The wandering eleven,
All join to chant the dirge of him
Who fell just now from Heaven.

GEORGE DARLEY

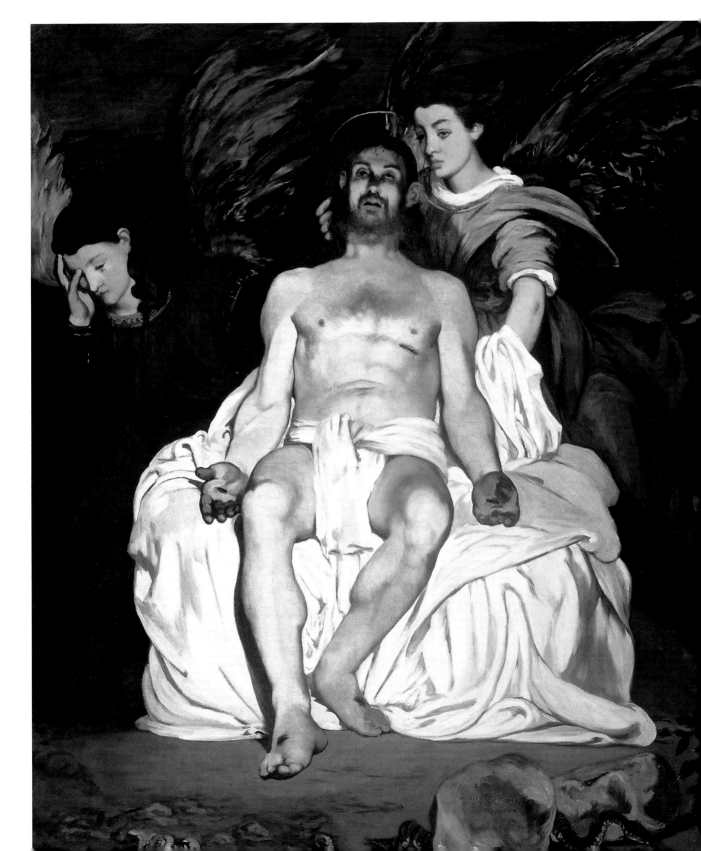

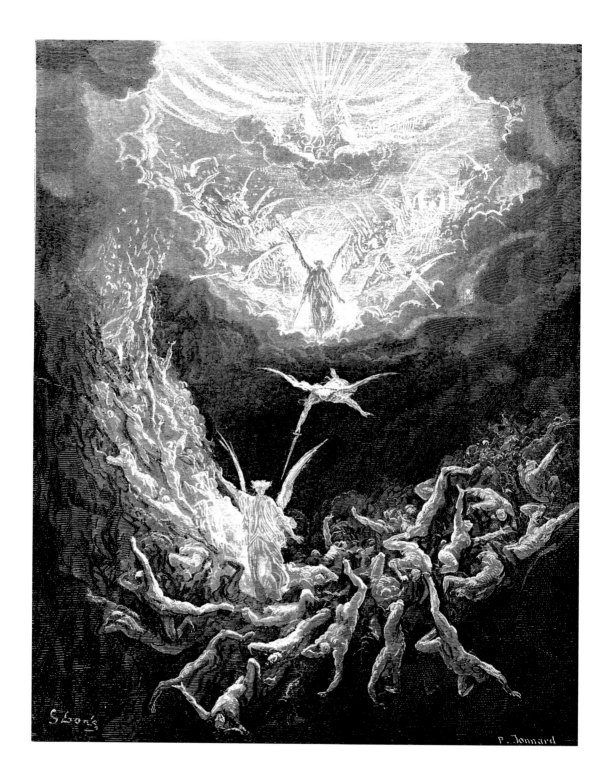

The Fall of Satan (Book I)

... He it was whose guile,
Stirred up with envy and revenge, deceived
The mother of mankind, what time his pride
Had cast him out from Heaven, with all his host
Of rebel Angels, by whose aid, aspiring
To set himself in glory above his peers,
He trusted to have equalled the Most High,
If he opposed, and with ambitious aim
Against the throne and monarchy of God,
Raised impious war in Heaven
 and battle proud,
With vain attempt. Him the
Almighty Power

Hurled headlong flaming from th'
 ethereal sky,
With hideous ruin and combustion,
 down
To bottomless perdition, there to dwell
In adamantine chains and penal fire,
Who durst defy th' Omnipotent to
 arms.

JOHN MILTON | *"Paradise Lost"*

GUSTAVE DORÉ | *"The Last Judgment" (1866)*
Woodcut, 35 x 25 cm
From: *Illustrated Bible*, Mame & Fils, Tours

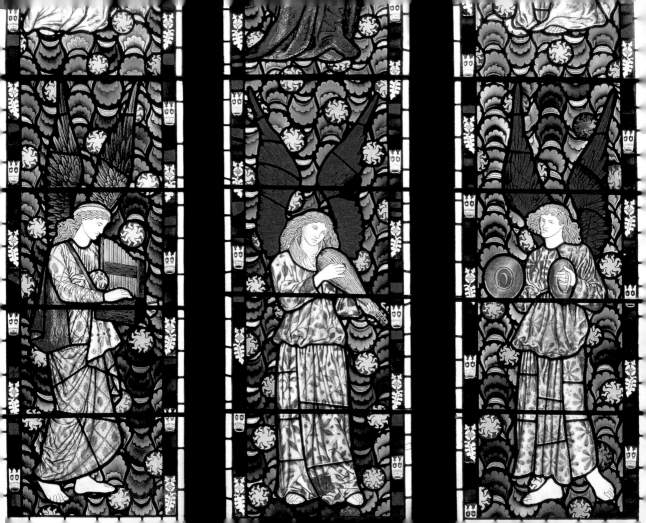

Israfel

In Heaven a spirit doth dwell
"Whose heart-strings are a lute";
None sing so wildly well
As the angel Israfel,
And the giddy stars (so legends tell),
Ceasing their hymns, attend the spell
Of his voice, all mute.

Tottering above
In her highest noon,
The enamoured moon
Blushes with love,
While, to listen, the red levin
(With the rapid Pleiads, even,
Which were seven,)
Pauses in Heaven.

And they say (the starry choir
And the other listening things)
That Israfeli's fire
Is owing to that lyre
By which he sits and sings–
The trembling living wire
Of those unusual strings.

But the skies that angel trod,
Where deep thoughts are a duty–
Where Love's a grown-up God–
Where the Houri glances are
Imbued with all the beauty
Which we worship in a star.

Therefore thou art not wrong,
Israfeli, who despisest
An unimpassioned song;
To thee the laurels belong,
Best bard, because the wisest!
Merrily live, and long!

The ecstasies above
With thy burning measures suit–
Thy grief, thy joy, thy hate, thy love,
With the fervor of thy lute–
Well may the stars be mute!

Yes, Heaven is thine; but this
Is a world of sweets and sours;
Our flowers are merely–flowers,
And the shadow of thy perfect bliss
Is the sunshine of ours.

If I could dwell
Where Israfel
Hath dwelt, and he where I,
He might not sing so wildly well
A mortal melody,
While a bolder note than this might swell
From my lyre within the sky.

EDGAR ALLAN POE

WILLIAM MORRIS
"Angels playing medieval music" (1869)
Stained-glass window
St Michael's Church, Tilehurst, Berkshire

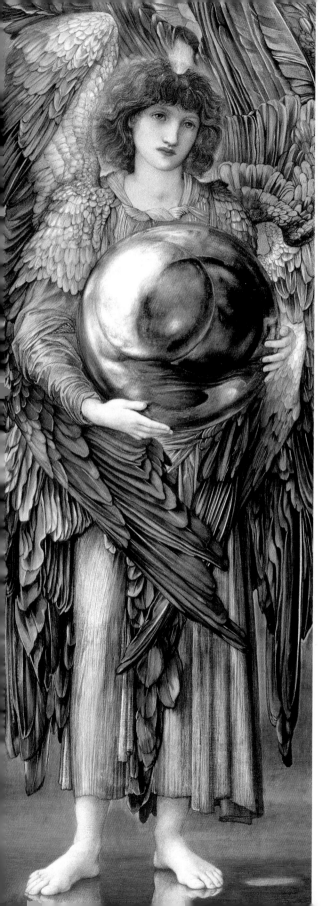

"We saw a world which was
both ancient, mythological even,
and yet Christian, nay English,
through and through. They were
figures with an almost mystic
sadness in their eyes which were
filled with longing, and they
displayed the naive marionette-
like gestures of childlike periods of
art. They were thereby involved
in allegorical actions and suffering
of endless import. We saw
beings whose slender, sometimes
hermaphroditic grace at first sight

EDWARD BURNE-JONES
"The Days of Creation, Panels I and VI" (1872–1876)
6 panels, watercolor, gouache, shell gold and platinum
paint on linen-covered panel,
c. 101.9 x 34.3 cm each
Fogg Art Museum, Cambridge, Massachusetts

had nothing unearthly about it; we saw them delicately occupied with the tools and symbols of worldly vanity … Studying the scene more carefully, however, we saw still more. These beautiful beings had an intensive, albeit strictly limited inner life. They were very simple, simpler than humans are, as simple as profound myths, as simple as the mythical form whose dream life, whose odyssey and metamorphoses we all incessantly think up within ourselves."

HUGO VON HOFMANNSTHAL
on Edward Burne-Jones, 1894

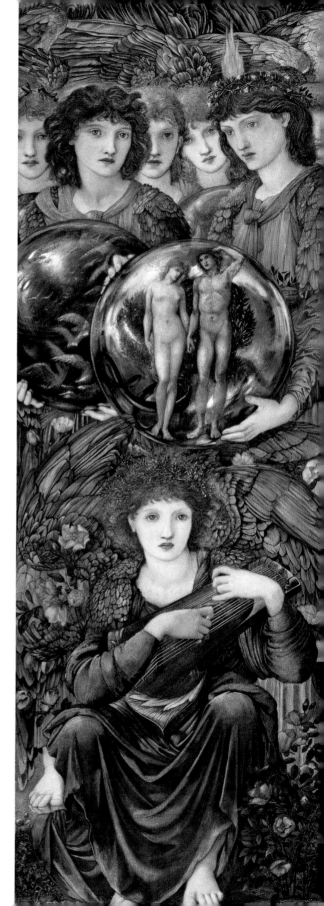

Sun

Angel, king of streaming morn;
Cherub, call'd by Heav'n to shine;
T'orient tread the waste forlorn;
Guide aetherial, pow'r divine;
Thou, Lord of all within!

Golden spirit, lamp of day,
Host, that dips in blood the plain,
Bids the crimson'd mead be gay,
Bids the green blood burst the vein;
Thou, Lord of all within!

Soul, that wraps the globe in light;
Spirit, beckoning to arise;
Drives the frowning brow of night,
Glory bursting o'er the skies;
Thou, Lord of all within!

HENRY ROWE

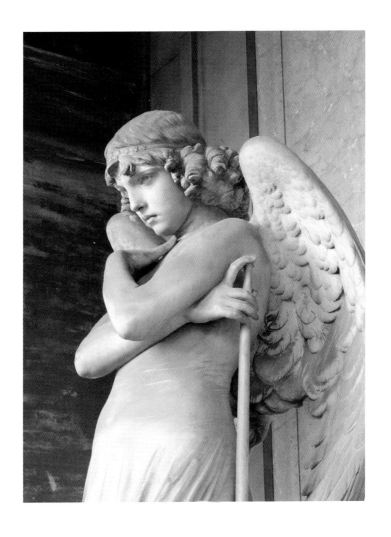

GIULIO MONTEVERDE | *"The Angel"*
Oneto family tomb
Camposanto di Staglieno, Genoa

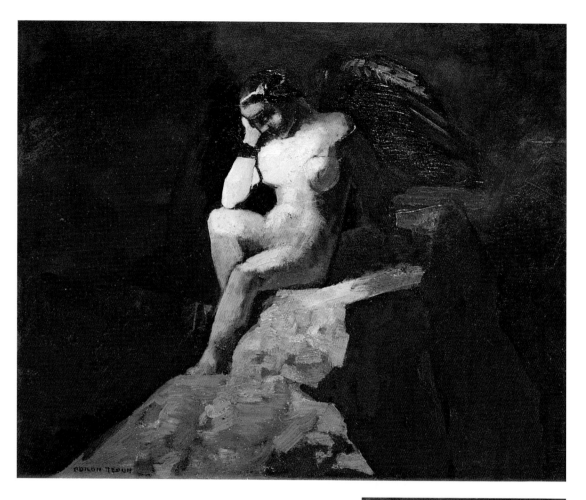

ODILON REDON | *"The Thinker" (1875)*
Oil on paper on cardboard, 22 x 26 cm
The Ian Woodner Family Collection, New York

ODILON REDON | *"The Fallen Angel" (1871)*
Charcoal on paper, 28 x 22.5 cm
Rijksmuseum Kröller-Müller, Otterlo

opposite
ODILON REDON | *"Old Man with Wings and a Beard"*
(c. 1895)
Pastel on paper, 56.9 x 39.7 cm
Musée d'Orsay, Paris
It is rare that an angel is represented as an old man, as he is here.
The depiction is reminiscent of a prophet.

60

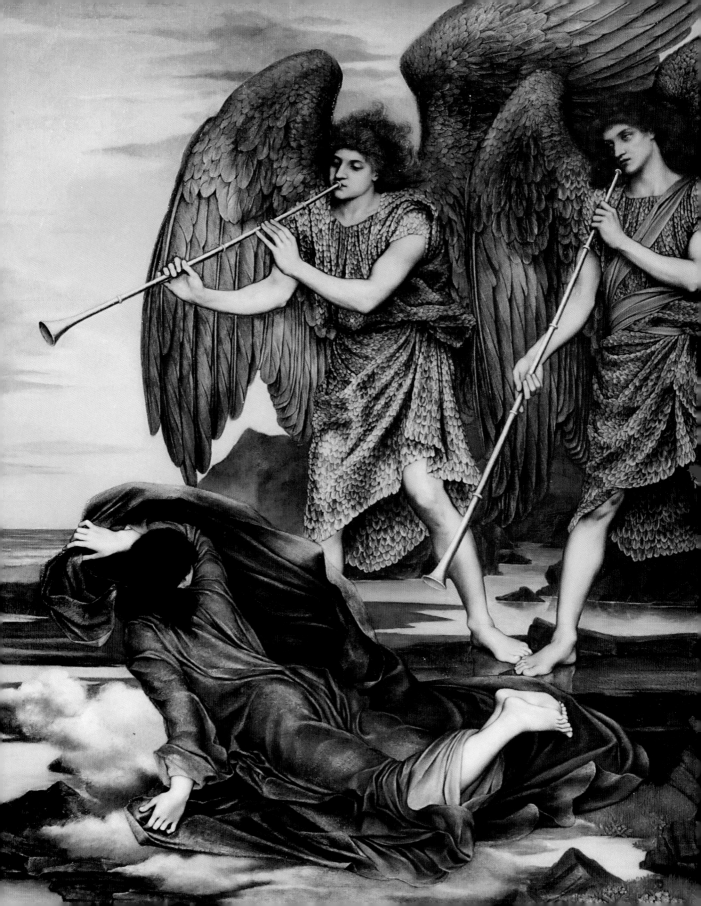

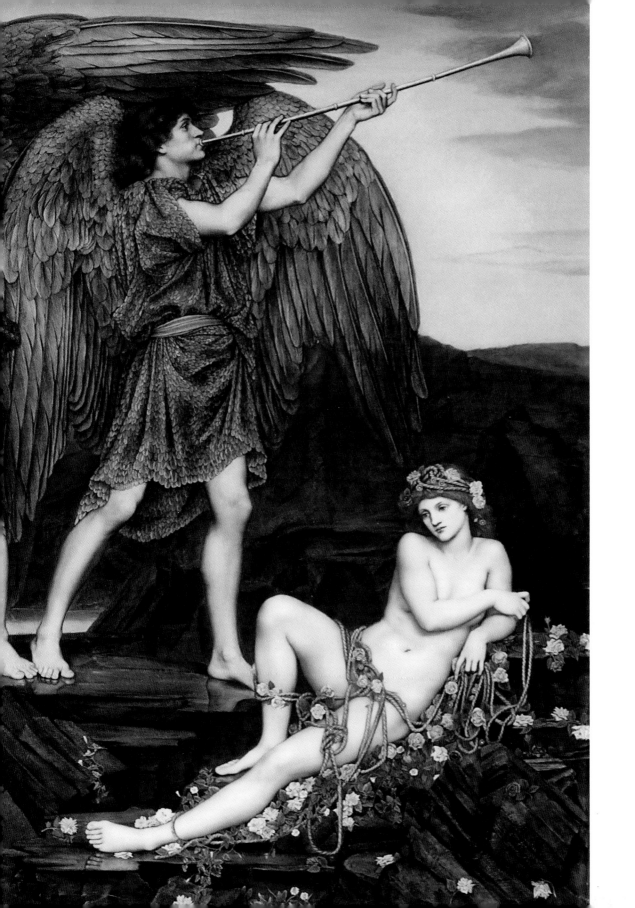

The Annunciation

Not that an angel entered (realize this),
scared her. Just as others would not startle
if a ray of sunlight or the moon at night
busied itself in the room, the form in which
an angel walked, did not scare her;
she barely had an idea that this stay was
difficult for angels. (O if we knew just how pure
she was. A doe once beheld her in the forest and
became so fond of her that within her was conceived
the unicorn, the animal from light, the pure animal.)

...

RAINER MARIA RILKE

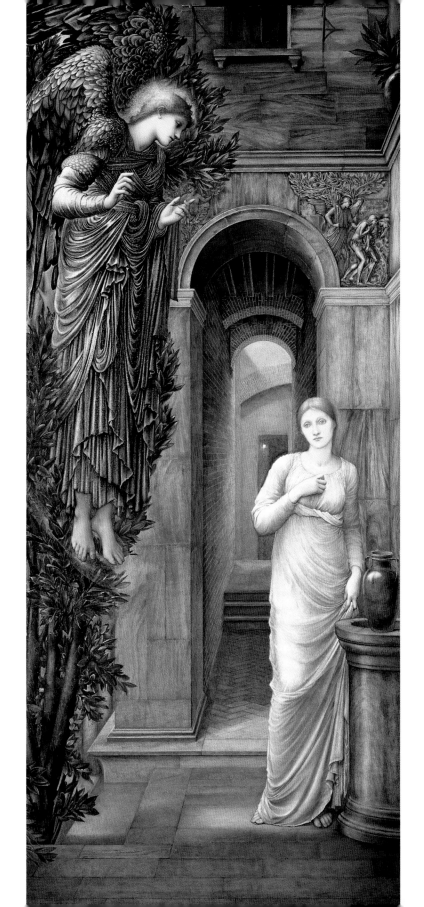

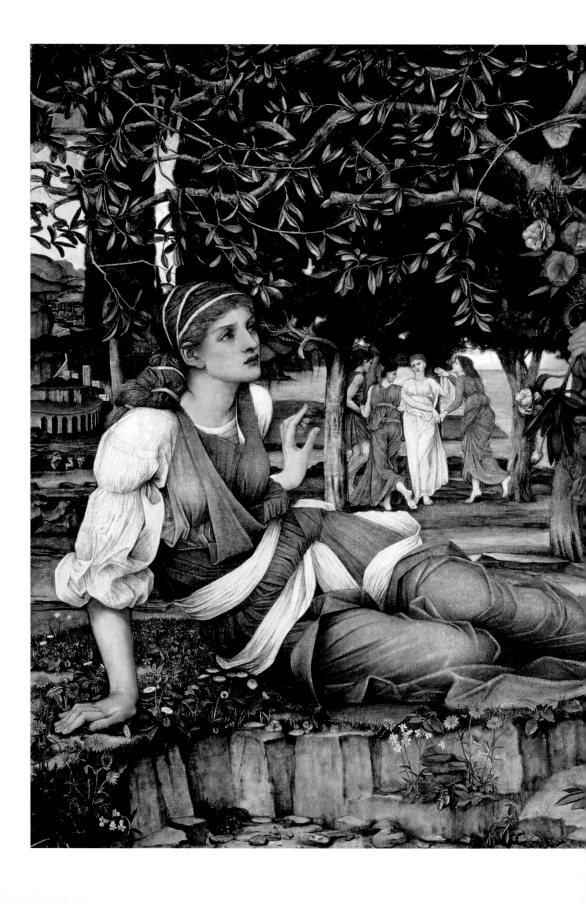

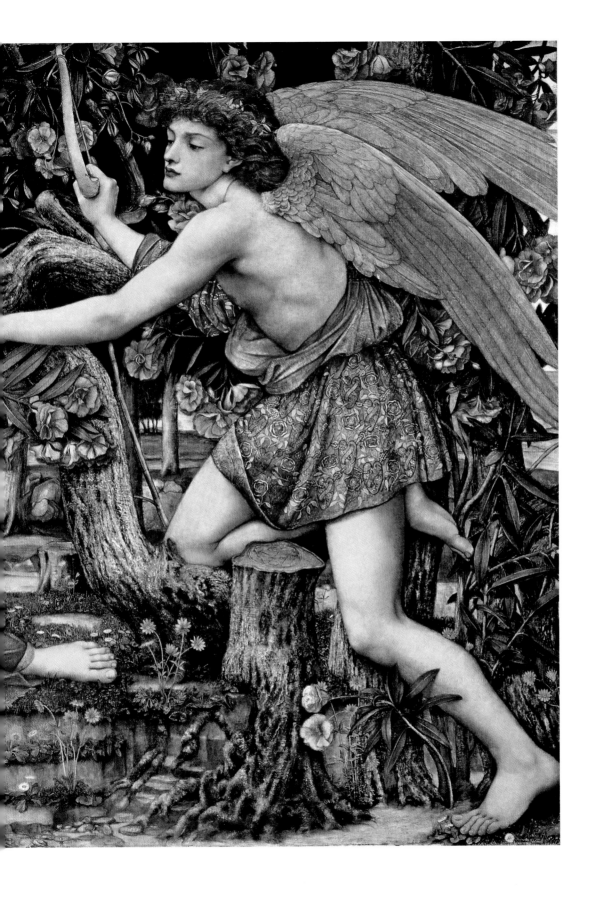

"...the more materialistic science becomes, the more I shall paint angels: their wings are my protest in favour of the immortality of the soul."

EDWARD BURNE-JONES

previous doublepage
JOHN RODDAM SPENCER STANHOPE
"Love and the Maiden" (1877)
Oil on canvas, 135.6 x 200 cm
Private collection

EDWARD BURNE-JONES | *"Love" (c. 1880)*
Watercolor and tempera, 211 x 107 cm
Victoria and Albert Museum, London

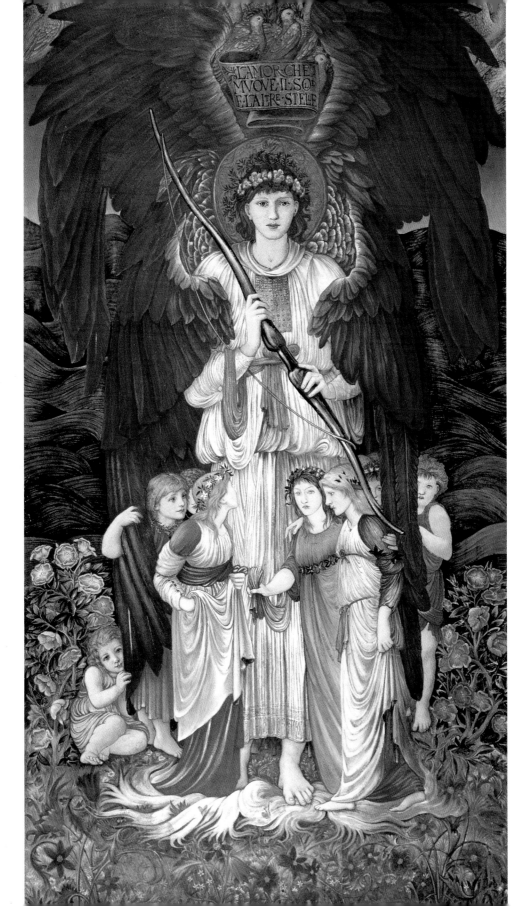

Through Death to Love

Like labour-laden moonclouds faint to flee
From winds that sweep the winter-bitten wold,—
Like multiform circumfluence manifold
Of night's flood-tide,—like terrors that agree
Of hoarse-tongued fire and inarticulate sea,—
Even such, within some glass dimm'd by our breath,
Our hearts discern wild images of Death,
Shadows and shoals that edge eternity.

EDWARD BURNE-JONES
"The Morning of the Resurrection" (1882)
Oil on canvas, 82.55 x 152.4 cm
Private collection

Howbeit athwart Death's imminent shade doth soar
One Power, than flow of stream or flight of dove
Sweeter to glide around, to brood above.
Tell me, my heart,—what angel-greeted door
Or threshold of wing-winnow'd threshing-floor
Hath guest fire-fledg'd as thine, whose lord is Love?

D<small>ANTE</small> G<small>ABRIEL</small> R<small>OSSETTI</small>

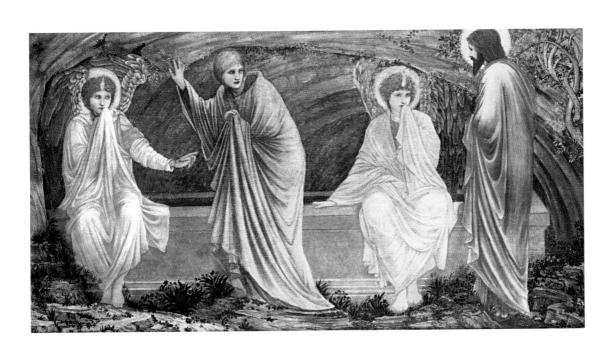

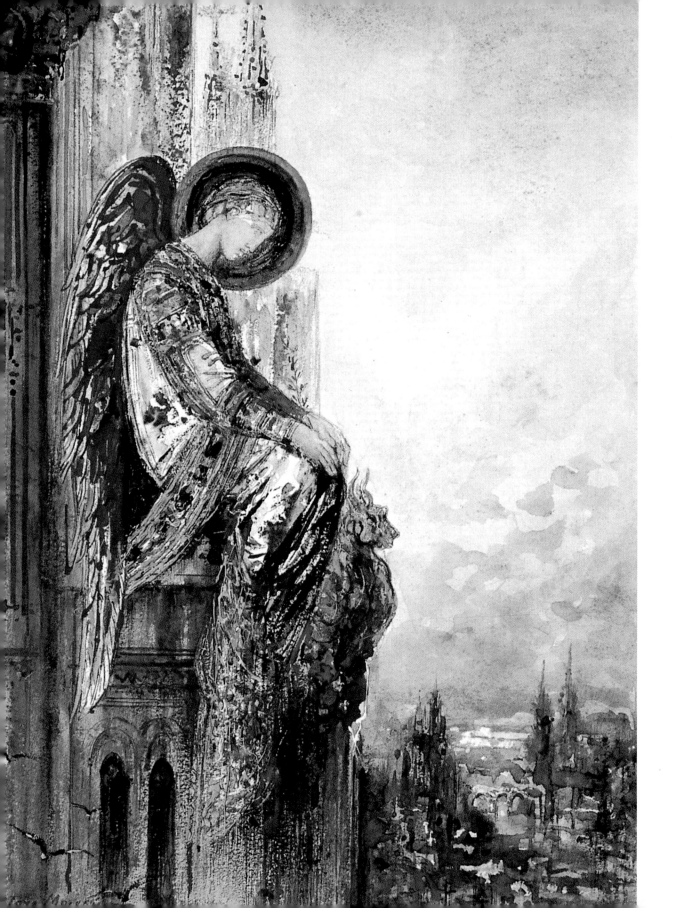

GUSTAVE MOREAU | *"Angel Traveller"*
(c. 1885)
Watercolor, 30 x 23 cm
Musée National Gustave Moreau, Paris

GUSTAVE MOREAU | *"The Angels of Sodom"*
(c. 1885)
Oil on canvas, 93 x 62 cm
Musée National Gustave Moreau, Paris
Two angels without wings hover above the burning city
of Sodom with raised swords, their presence announcing
impending disaster.

The Olive Garden

He went up under the gray leaves
All gray and lost in the olive lands
And laid his forehead, gray with dust,
Deep in the dustiness of his hot hands.

After everything this. And this was the end.
Now I must go, as I am going blind.
And why is it Thy will that I must say
Thou art, when I myself no more can find
 Thee.

I find Thee no more. Not in me, no.
Not in others. Not in this stone,
I find Thee no more. I am alone.

I am alone with all men's sorrow –
All that, through Thee, I thought to lighten,
Thou who art not, O nameless shame …

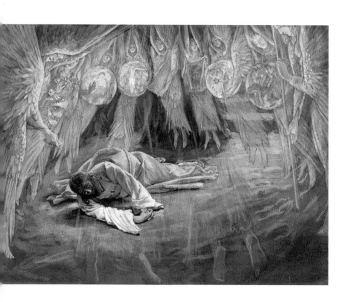

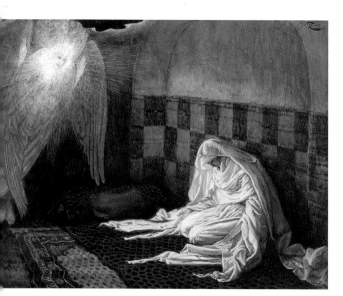

JAMES TISSOT | *"The Grotto of the Agony"*
from the series: *"The Life of Our Lord Jesus Christ"*
(1886–1894)
Watercolor on paper, 28.1 x 36.7 cm
Brooklyn Museum, New York

JAMES TISSOT | *"The Annunciation"*
from the series: *"The Life of Our Lord Jesus Christ"*
(1886–1894)
Watercolor on paper, 17 x 21.6 cm
Brooklyn Museum, New York
Tissot presents the scene of the Annunciation in an
"oriental" setting. The mother of God is wrapped in
a wide, oriental gown that is white (the color of purity).

Men said, later: an angel came.

Why an angel? Alas, there came the night,
And leafed through the trees, indifferently.
The disciples moved a little in their dreams.
Why an angel? Alas, there came the night.

The night that came was no uncommon night:
So hundreds of nights go by.
There dogs sleep; there stones lie,
Alas a sorrowful, alas any night
That waits till once more it is morning.

For then beseech: the angels do not come,
Never do nights grow great around them.
Who lose themselves, all things let go;
They are renounced by their own fathers
And shut from their own mothers' hearts.

RAINER MARIA RILKE

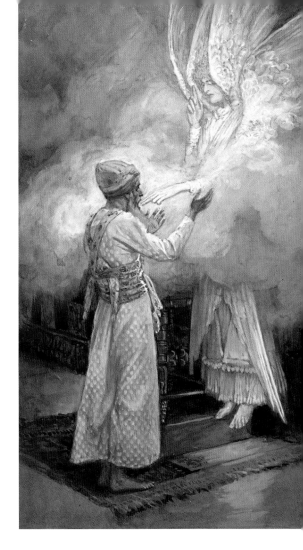

JAMES TISSOT | *"The Vision of Zacharias"*
from the series: *"The Life of Our Lord Jesus Christ"*
(1886–1894)
Watercolor on paper, 23.8 x 13.3 cm
Brooklyn Museum, New York
*The angel of the Lord, who announces to Zacharias that
he will have a son named John, causes Zacharias to
become mute. Zacharias will not be able to speak again
until the prophecy has been fulfilled.*

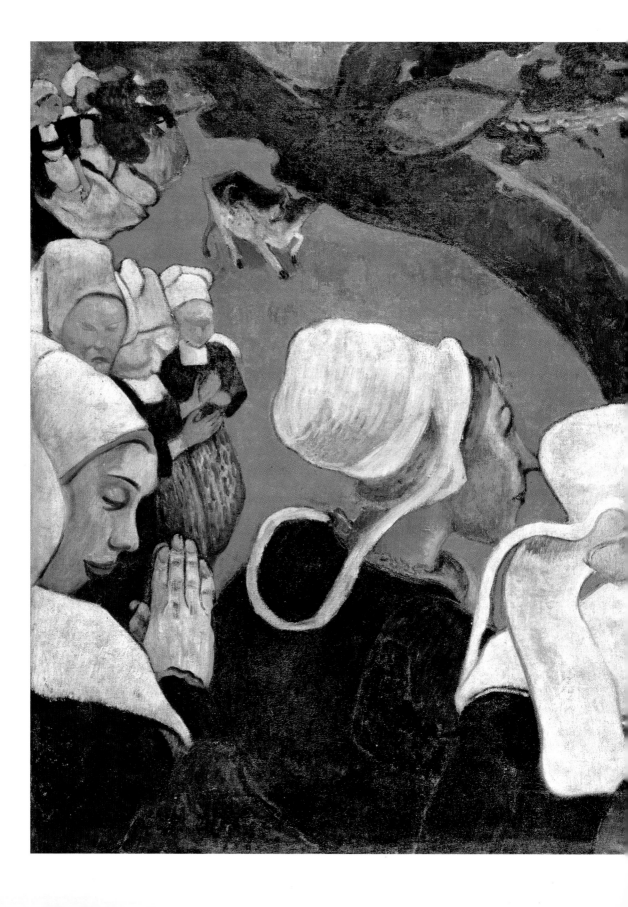

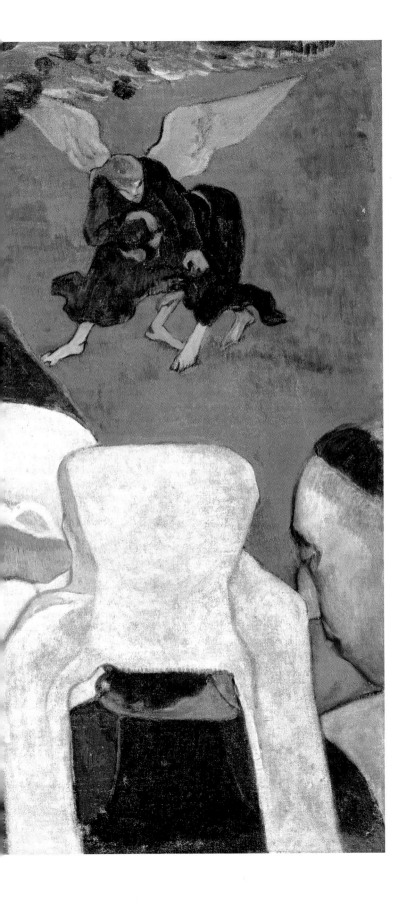

PAUL GAUGUIN
*"Vision of the Sermon (Jacob
Wrestling with the Angel)" (1888)*
Oil on canvas, 73 x 92 cm
National Gallery of Scotland,
Edinburgh
*Jacob's fight with the angel is presented
as the vision of Breton peasant women.*

next doublepage
EDWARD BURNE-JONES
*"The Adoration of the Magi"
(Designed 1888, woven 1900)*
Wool-and-silk tapestry,
258 x 384 cm
Museum für Kunst und Gewerbe,
Hamburg

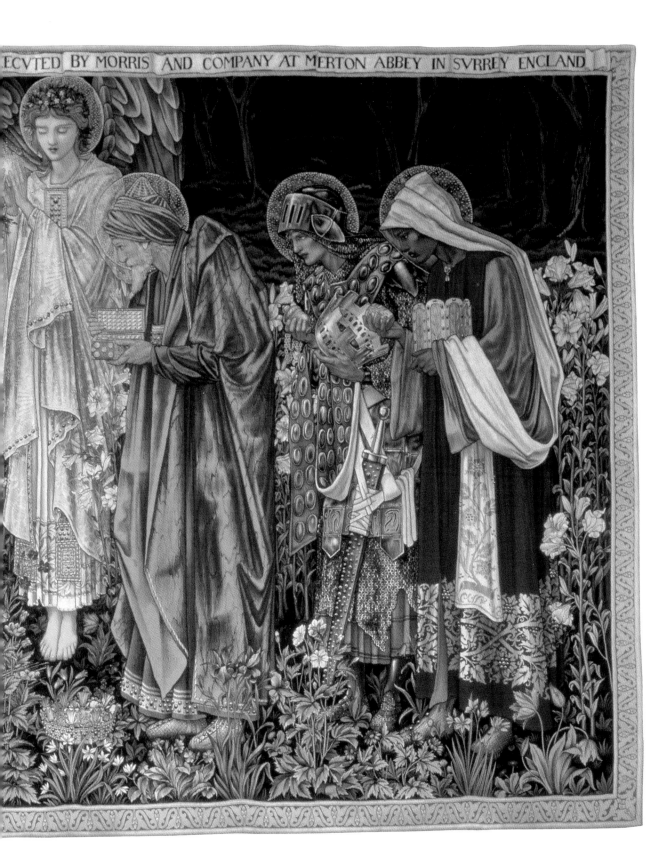

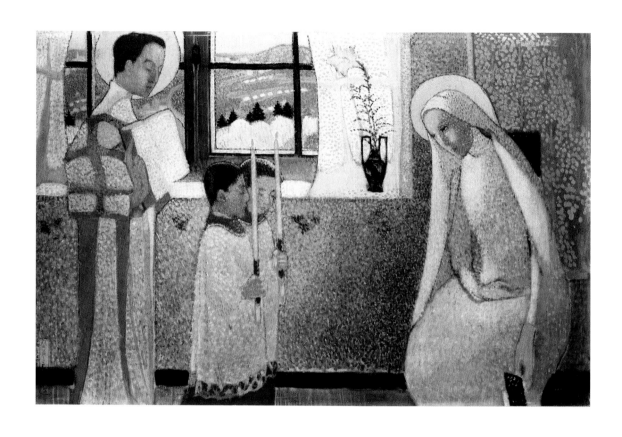

Ave

…

The cherubim, succinct, conjoint,
Float inward to a golden point,
And from between the seraphim
The glory issues for a hymn.
O Mary Mother, be not loth
To listen,—thou whom the stars clothe,
Who seest and mayst not be seen!
Hear us at last, O Mary Queen!
Into our shadow bend thy face,
Bowing thee from the secret place,
O Mary Virgin, full of grace!

DANTE GABRIEL ROSSETTI

MAURICE DENIS | *"Catholic Mystery" (1889)*
Oil on canvas, 97 x 143 cm
Musée départemental Maurice Denis,
Saint-Germain-en-Laye
The Annunciation is made to the mother of God not by the
herald angel Gabriel , but by a deacon and two choir boys.

JAMES ENSOR | *"The Fall of the Rebel Angels"* (*1889*)
Oil on canvas, 108 x 132 cm
Koninklijk Museum voor Schone Kunsten, Antwerp
*Ensor's dramatic painting depicts the battle between the good
and the rebellious angels.*

82

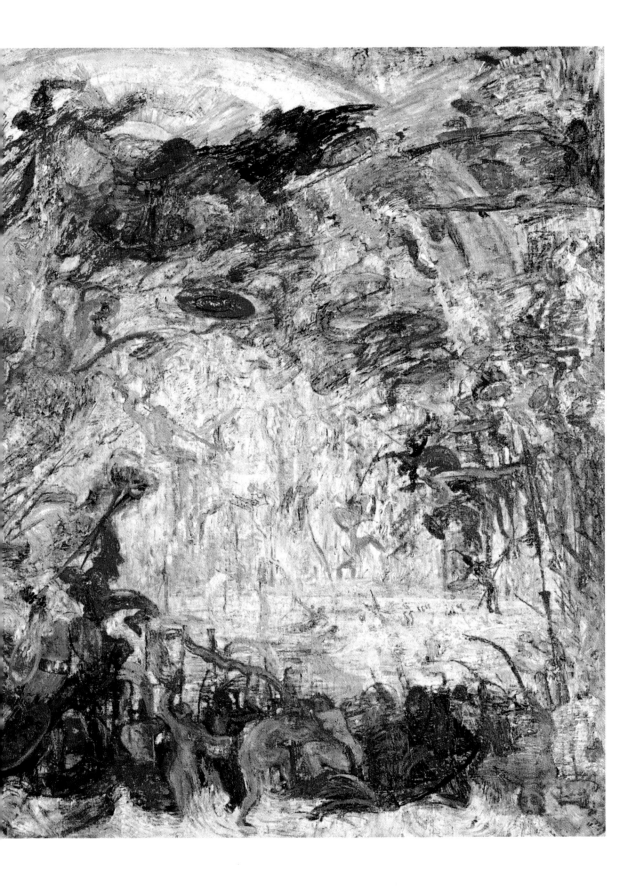

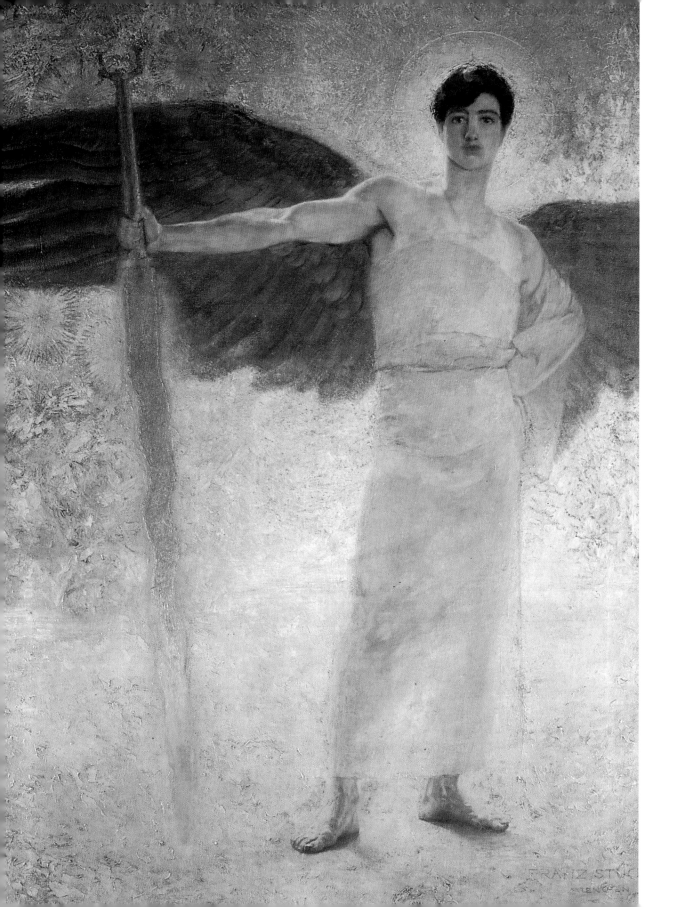

"It is not known precisely where angels dwell – whether in the air, the void, or the planets. It has not been God's pleasure that we should be informed of their abode."

VOLTAIRE | *"Philosophical Dictionary"*

FRANZ VON STUCK | *"The Guardian of Paradise"* (1889)
Oil on canvas, 250.5 x 167.5 cm
Museum Villa Stuck, Munich/Ziersch collection

Lucifer in Starlight

On a starr'd night Prince Lucifer uprose.
Tired of his dark dominion swung the fiend
Above the rolling ball in cloud part screen'd,
Where sinners hugg'd their spectre of repose.
Poor prey to his hot fit of pride were those.
And now upon his western wing he lean'd,
Now his huge bulk o'er Afric's sands careen'd,
Now the black planet
Shadow'd Arctic
snows.

Soaring through wider zones that prick'd his scars
With memory of the old revolt from Awe,
He reach'd a middle height, and at the stars,
Which are the brain of heaven, he look'd, and
sank.
Around the ancient track march'd, rank on rank,
The army of unalterable law.

GEORGE MEREDITH

FRANZ VON STUCK | *"Lucifer" (1890)*
Oil on canvas, 161 x 152 cm
National Gallery for Foreign Art, Sofia

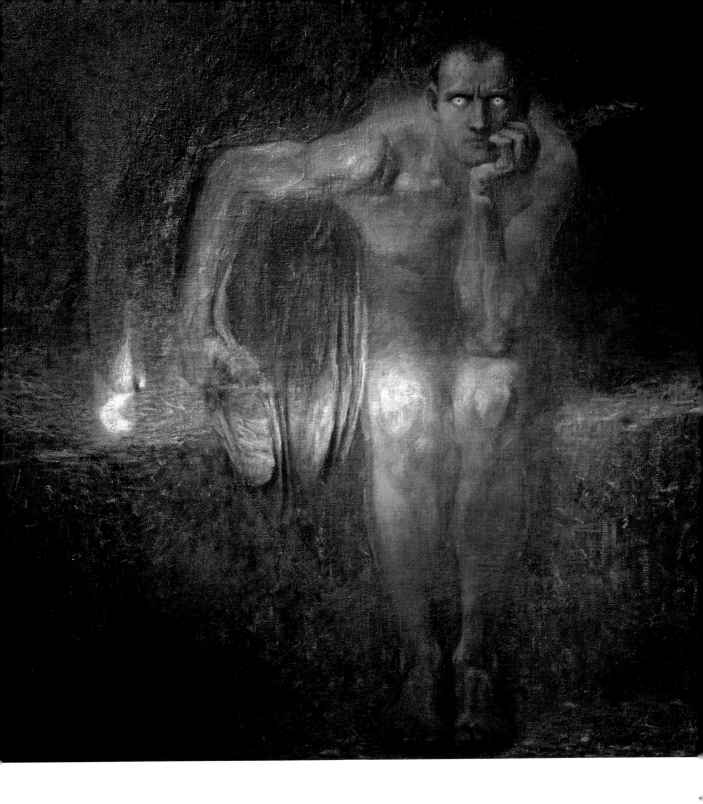

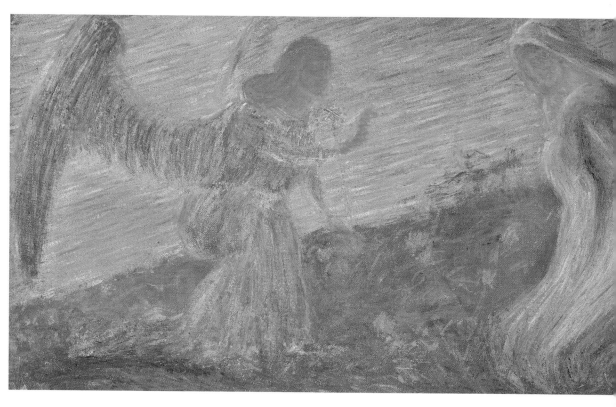

GAETANO PREVIATI | *"Annunciation"* (*1912*)
Oil on canvas
Civica Galleria d'Arte Moderna, Milan

GAETANO PREVIATI | *"Motherhood"* (*1890–1891*)
Oil on canvas, 174 x 411 cm
Banca Popolare di Novare

MAURICE DENIS | *"Jacob's Battle with the Angel"* (*1893*)
Oil on canvas, 48 x 36 cm
Josefowitz collection, Lausanne

91

EDWARD BURNE-JONES
"The Fall of Lucifer" (1894)
Gouache and gold paint on paper, laid down on canvas, 245 x 118 cm
Andrew Lloyd Webber Collection
The good angels, dressed in full armor, follow Saint Michael to expel the rebellious Lucifer.

EDWARD BURNE-JONES
"Angeli Ministrantes"
Woven by Morris & Co., (1894)
Tapestry of wool, silk and mohair, 241.5 x 200 cm
Victoria and Albert Museum, London

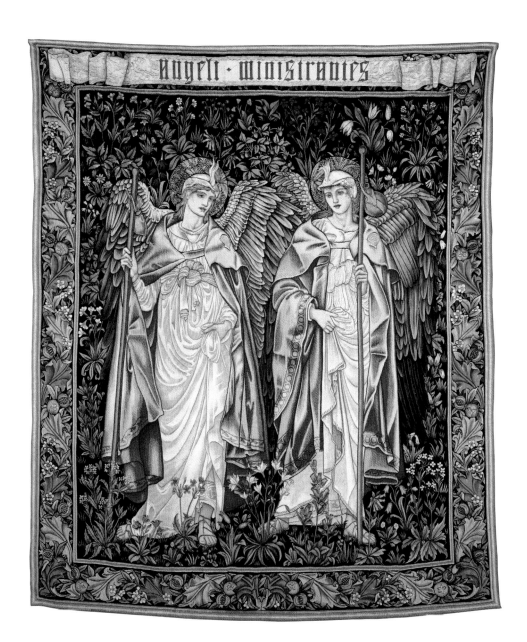

Sweet Death

The sweetest blossoms die.
And so it was that, going day by day
Unto the church to praise and pray,
And crossing the green churchyard
 thoughtfully,
I saw how on the graves the flowers
Shed their fresh leaves in showers,
And how their perfume rose up to the sky
Before it passed away.

The youngest blossoms die.
They die, and fall and nourish the rich
 earth
From which they lately had their birth;
Sweet life, but sweeter death that passeth
 by

And is as though it had not been:–
All colors turn to green:
The bright hues vanish, and the odours
 fly,
The grass hath lasting worth.

And youth and beauty die.
So be it, O my God, Thou God of truth:
Better than beauty and than youth
Are Saints and Angels, a glad company;
And Thou, O lord, our Rest and Ease,
Are better far than these.
Why should we shrink from our full
 harvest? why
Prefer to glean with Ruth?

CHRISTINA ROSSETTI

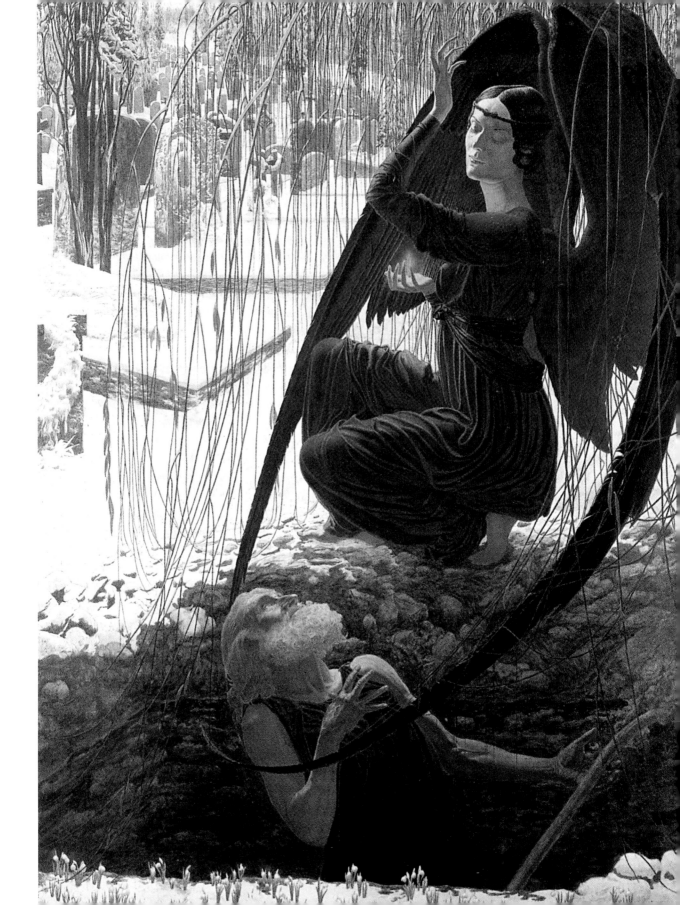

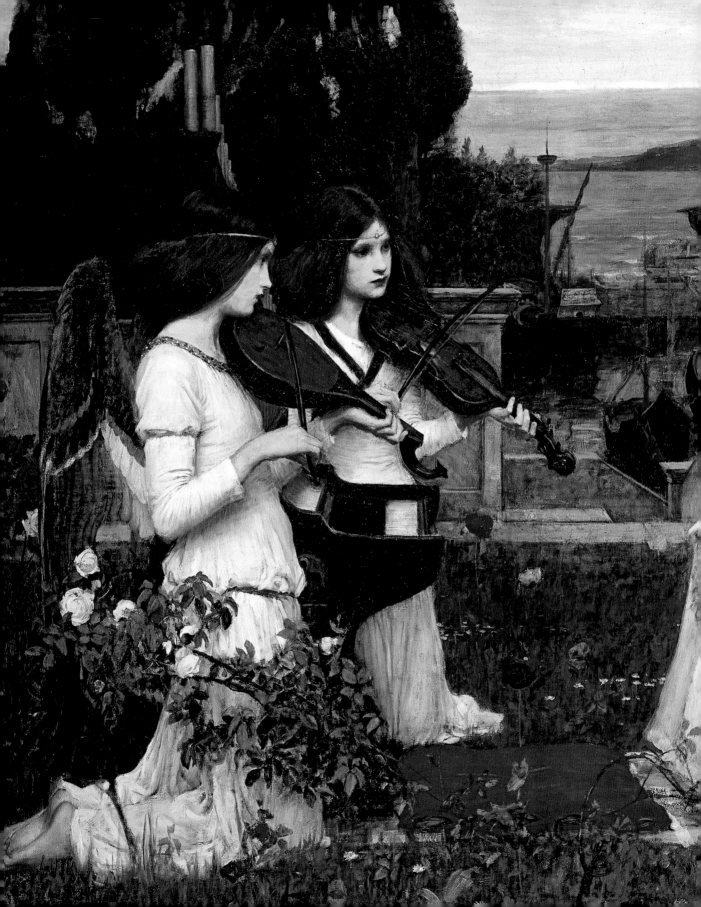

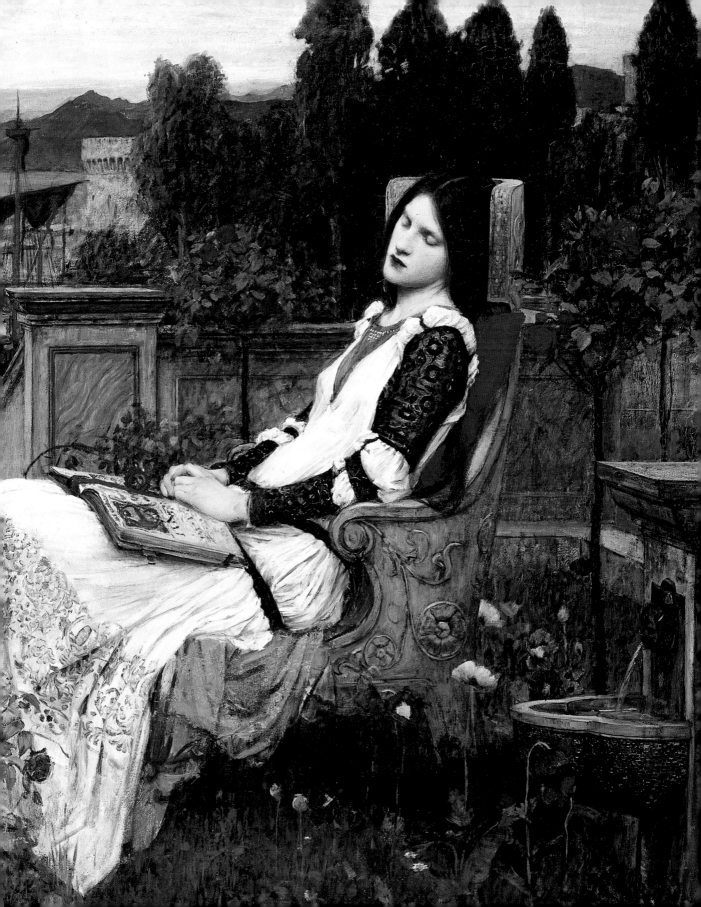

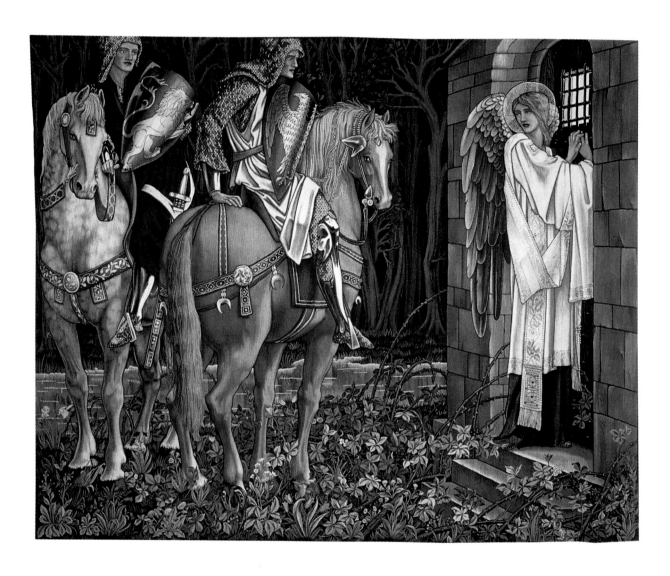

EDWARD BURNE-JONES | *"The Failure of Sir Gawaine: Sir Gawaine and Sir Uwaine at the Ruined Chapel"*
Woven by Morris & Co., *(1895–1896)*
Wool-and-silk tapestry, 243 x 296 cm
Birmingham Museums and Art Gallery, Birmingham

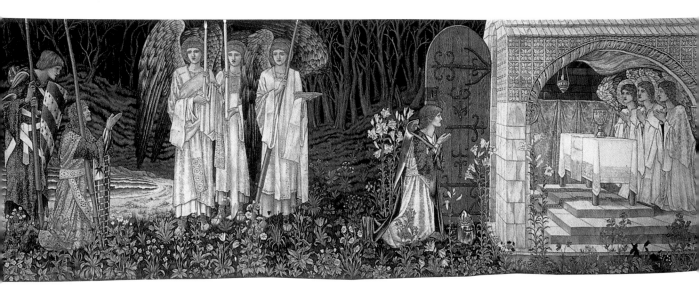

EDWARD BURNE-JONES | *"The Attainment:*
The Vision of the Holy Grail to Sir Galahad, Sir Bors
and Sir Percival"
Woven by Morris & Co., *(1895–1896)*
Wool-and-silk tapestry, 244 x 695 cm
Birmingham Museums and Art Gallery, Birmingham

The Angel

I dreamt a dream! What can it mean?
And that I was a maiden Queen
Guarded by an Angel mild:
Witless woe was ne'er beguiled!

And I wept both night and day,
And he wiped my tears away;
And I wept both day and night,
And hid from him my heart's delight.

So he took his wings, and fled;
Then the morn blushed rosy red.
I dried my tears, and armed my fears
With ten-thousand shields and spears.

Soon my Angel came again;
I was armed, he came in vain;
For the time of youth was fled,
And grey hairs were on my head.

WILLIAM BLAKE

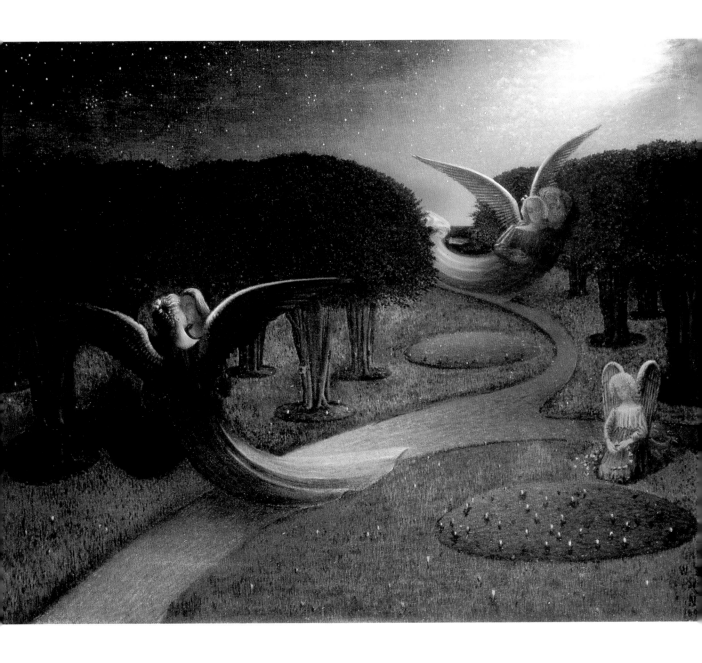

WILLIAM DEGOUVE DE NUNCQUES
"Angels of the Night" (1896)
Oil on canvas, 48 x 60.1 cm
Rijksmuseum Kröller-Müller, Otterlo

101

**GIOVANNI
SEGANTINI**
*"Love at the
Fountain of Life"*
(1896)
Oil on canvas,
70 x 98 cm
Galleria d'Arte
Moderna, Milan

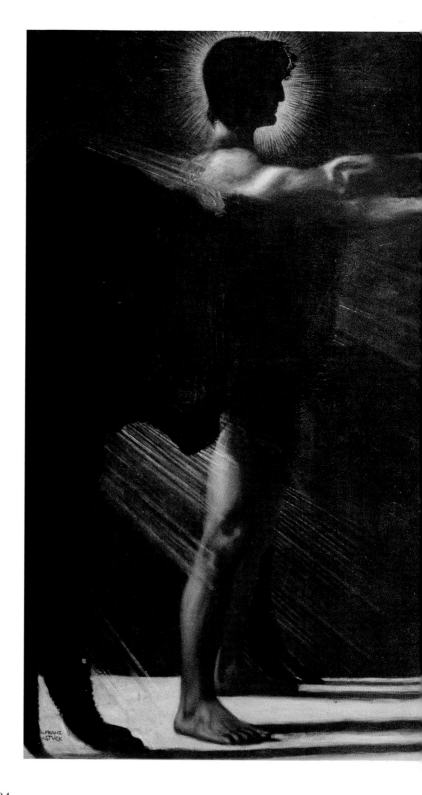

FRANZ VON STUCK
"The Expulsion of Adam and Eve
From Paradise" (1897)
Oil on canvas, 200 x 290 cm
Staatliche Kunstsammlungen
Dresden, Galerie Neue Meister
Aware that they have sinned, Adam
and Eve are expelled from Paradise.
An athletic angel armed with a sword
prevents them from returning.

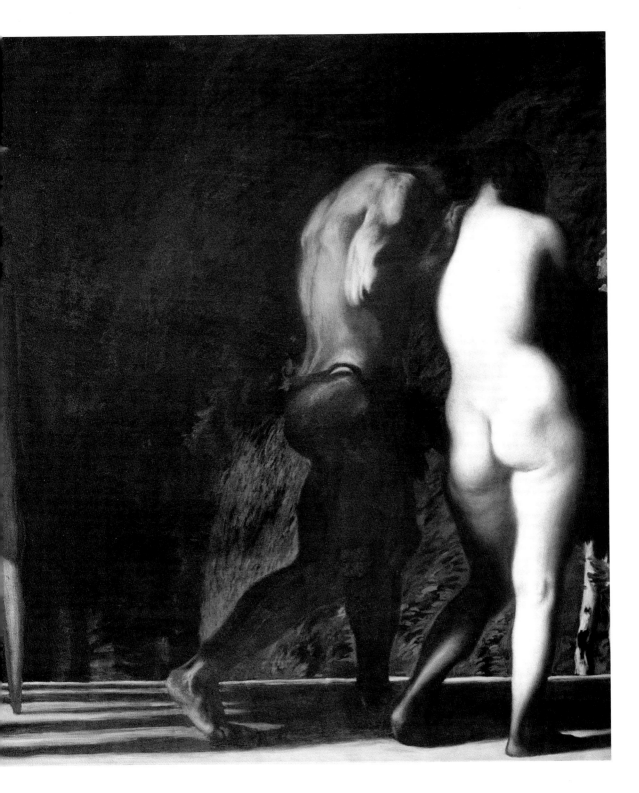

To the Angels

This is dread Thanatos – he rides
A pale white steed with winged strides.
I hear his hooves beat brazenly,
The night-black rider comes for me –
He tears me from Mathilde – I must
 leave –
The thought is one my heart cannot
 conceive!

Both wife and child she was to me,
And when I leave this earth she'll be
A widow and an orphan both!
Dear wife and child, how I am loth
To leave her here who trustingly did rest
Her carefree, faithful head upon my
 breast.

You angels up in Heaven, see
My sobs and sorrow, hear my plea:
When I lie on my lonely bier,
Protect the wife I loved down here;
O guard a soul like yours, like angels
 mild,
Protect and shield Mathilde, my poor
 child.

By all the tears you ever shed
On human woes uncomforted,
And by the awesome Word that's known
And said aloud by priests alone,
By your own beauty and all grace
 above,
I charge you, angels, guard my child, my
 love.

HEINRICH HEINE

WILLIAM ADOLPHE BOUGUEREAU
"Regina Angelorum" (1900)
Oil on canvas, 285 x 185 cm
Musée du Petit Palais, Paris

107

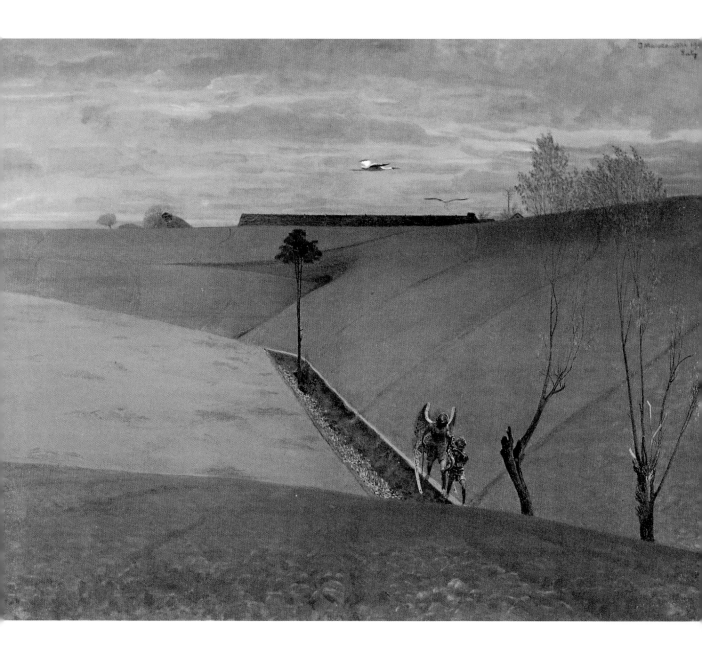

Every Angel is terror. And yet,
ah, knowing you, I invoke you, almost deadly
birds of the soul. Where are the days of Tobias
when one of the most radiant of you stood at the simple
* threshold,*
disguised somewhat for the journey and already no
* longer awesome*
(Like a youth, to the youth looking out curiously).
Let the Archangel now, the dangerous one, from behind
* the stars,*
take a single step down and toward us: our own heart,
beating on high would beat us down. What are you?

RAINER MARIA RILKE | *"Duino Elegies", The Second Elegy*

JACEK MALCZEWSKI
"Spring – Landscape with Tobias" (1904)
Oil on canvas, 76 x 97 cm
National Museum, Poznań

The Prophet

Longing for spiritual springs,
I dragged myself through desert sands ...
An angel with three pairs of wings
Arrived to me at cross of lands;
With fingers so light and slim
He touched my eyes as in a dream:
And opened my prophetic eyes

Like eyes of eagle in surprise.
He touched my ears in movement, single,
And they were filled with noise and jingle:
I heard a shuddering of heavens,
And angels' flight on azure heights
And creatures' crawl in long sea nights,
And rustle of vines in distant valleys.
And he bent down to my chin,
And he tore off my tongue of sin,
In cheat and idle talks aroused,
And with his hand in bloody specks
He put the sting of wizard snakes
Into my deadly stoned mouth.
With his sharp sword he cleaved my breast,
And plucked my quivering heart out,
And coals flamed with God's behest,
Into my gaping breast were ground.
Like dead I lay on desert sands,
And listened to the God's commands:
"Arise, O prophet, hark and see,
Be filled with utter My demands,
And, going over Land and Sea,
Burn with your Word the humane hearts."

ALEXANDER PUSHKIN

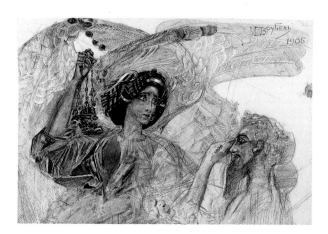

MIKHAIL VRUBEL | *"The Prophet"* (1905)
Watercolor and ink, with white highlights, on paper,
34.5 x 50 cm
The National Pushkin Museum, St. Petersburg

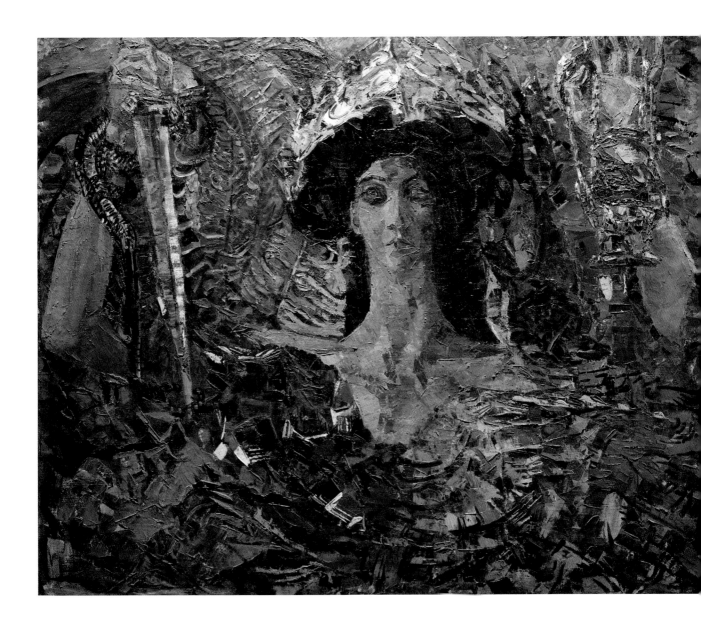

MIKHAIL VRUBEL
"Six-winged Seraph" (*1904*)
Oil on canvas, 131 x 155 cm
The Russian Museum, St. Petersburg

111

MIKALOJUS KONSTANTINAS ČIURLIONIS
"Little Angels (Paradise)" (1909)
Tempera on cardboard, 47 x 61.8 cm
Mikalojus Konstantinas Čiurlionis
National Art Museum, Kaunas
Numerous angels stroll about and pick flowers in an idealized landscape including step-shaped architecture, a meadow and the sea.

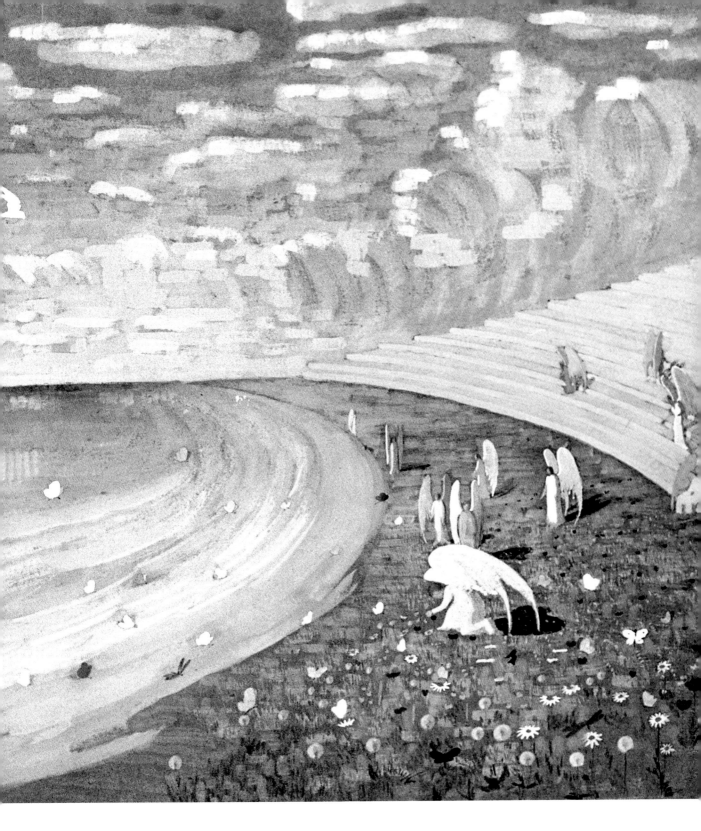

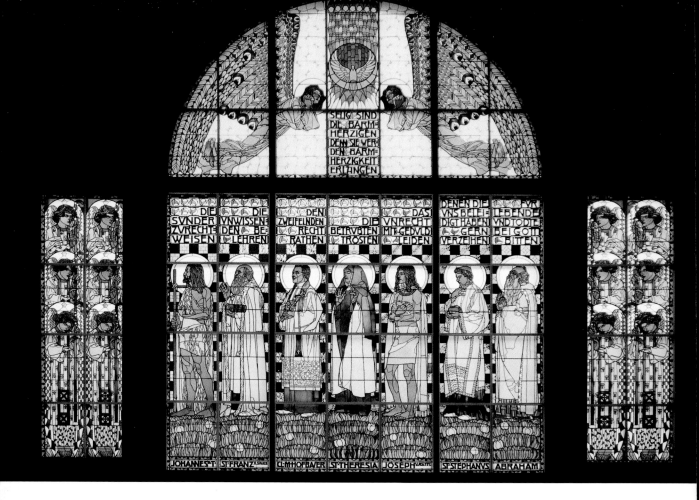

KOLOMAN MOSER
"The Spiritual Virtues" (1904–1907)
Stained-glass window
St. Leopold am Steinhof chapel, Vienna
Koloman Moser designed windows depicting the spiritual
virtues, surrounded by angelic figures, for this important
Art Nouveau church, built by Otto Wagner.

LOUIS COMFORT TIFFANY, TIFFANY STUDIOS
"Two Angels" (1910)
Stained-glass window
Courtesy of The Richard H. Driehaus Gallery of
Stained Glass, Chicago

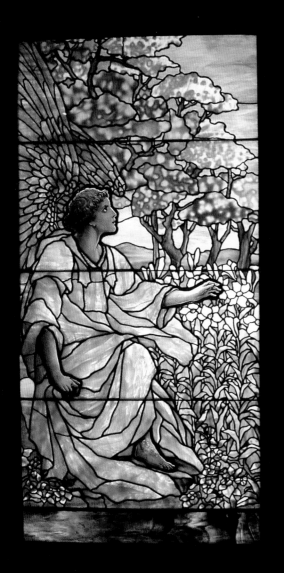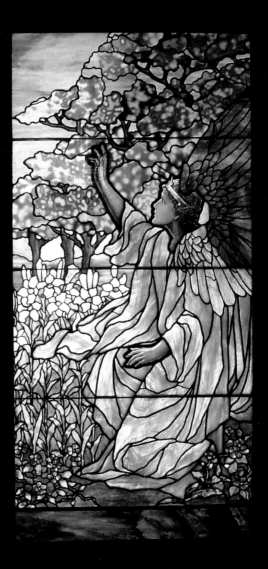

MAX ERNST | *"The Pool of Bethesda" (1911)*
Watercolor on cardboard, 53.5 x 42 cm
Kasimir Hagen collection,
Kunstgewerbemuseum, Cologne

WASSILY KANDINSKY | *"Saint Gabriel" (1911)*
Reverse glass painting, 40 x 25.3 cm
Städtische Galerie im Lenbachhaus, Munich
In contrast to traditional iconography, Kandinsky shows the
archangel Gabriel as the angel of the Last Judgment, holding
a trumpet and lifting his hand as a sign of warning.

116

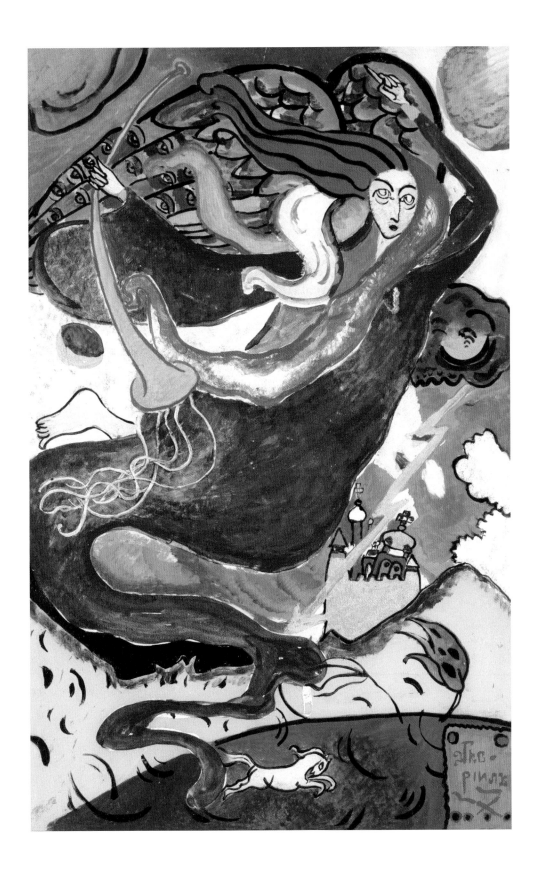

"It was wrong to do this," said the angel

"It was wrong to do this," said the angel.
"You should live like a flower,
 Holding malice like a puppy,
 Waging war like a lambkin."

"Not so," quoth the man
 Who had no fear of spirits;
"It is only wrong for angels
 Who can live like the flowers,
 Holding malice like the puppies,
 Waging war like the lambkins."

STEPHEN CRANE

PAUL KLEE | *"Angelus descendens" (1918)*
Ink and watercolor on paper, mounted on
cardboard, 15.3 x 10.2 cm
Private collection, Great Britain

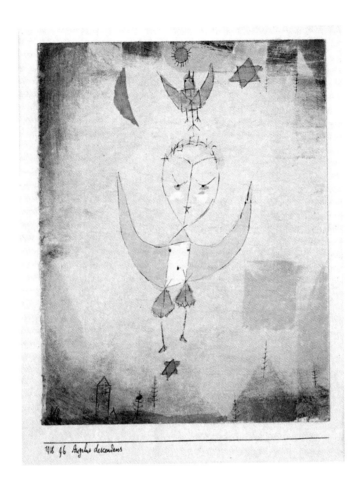

1918 96 Angelus descendens

"*I cannot be grasped in the here and now,*
For my dwelling place is as much among the dead,
As the yet unborn,
Slightly closer to the heart of creation than usual,
But still not close enough."

PAUL KLEE | *1920*

PAUL KLEE | *"Archangel" (1938)*
Oil paint and distemper on cotton, mounted on jute on
a stretcher frame, 100 x 65.5 cm
Städtische Galerie im Lenbachhaus, Munich,
on permanent loan from the Gabriele Münter
und Johannes Eichner-Stiftung foundation

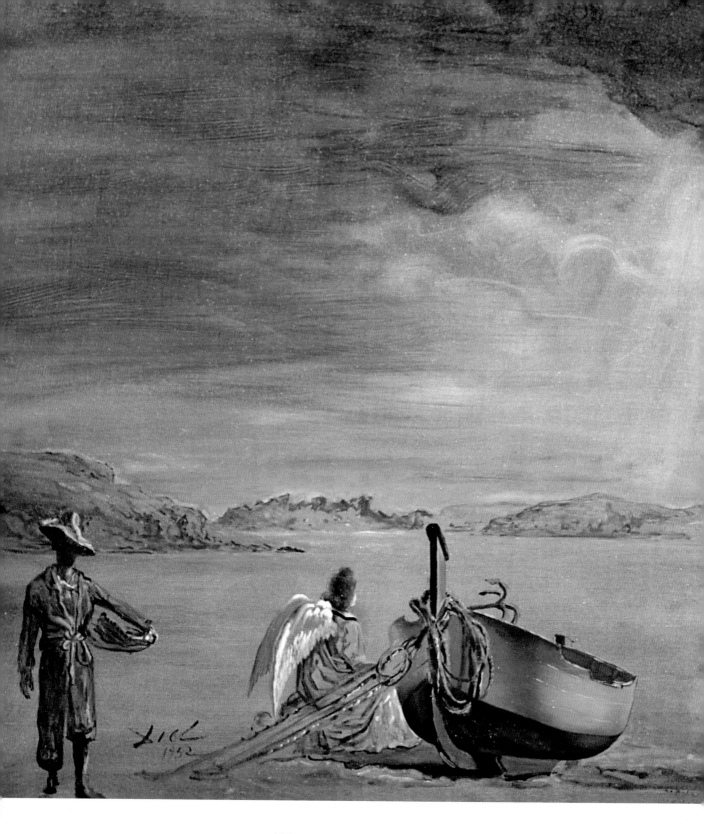

"Angels are the winged vehicle that leads to God. Mystics see the angels before they find God."

SALVADOR DALÍ

SALVADOR DALÍ | *"The Angel of Port Lligat"*
(1952)
Oil on canvas, 58 x 78.3 cm
The Salvador Dalí Museum, St. Petersburg,
Florida, on loan from E. and A. Reynolds
Morse

123

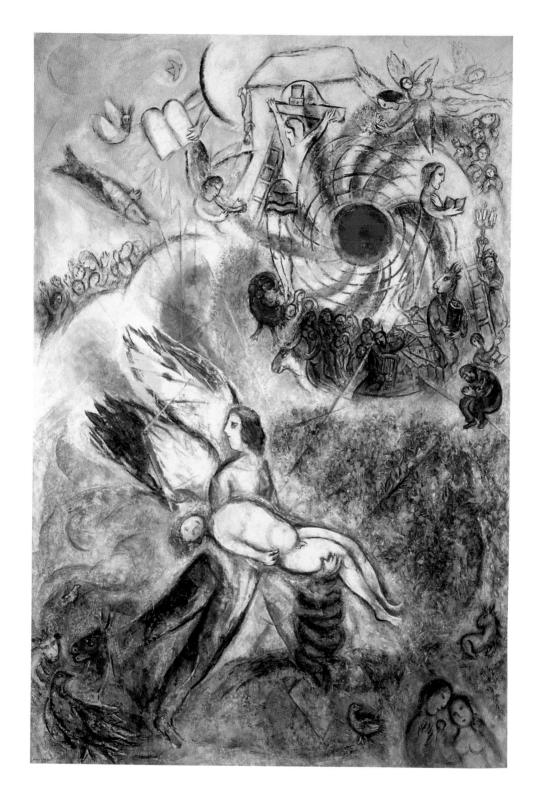

The Angel

At midnight an angel was crossing the sky,
And quietly he sang. …
He sang of the bliss of the innocent souls
In heavenly gardens above …
He bore in his arms a young soul
To our valley of sorrow and tears.

Mikhail Lermontov

Marc Chagall | *"The Creation of Man" (1956/1957)*
Oil on canvas, 299 x 200.5 cm
Musée National Message Biblique Marc Chagall, Nice

MARC CHAGALL
"Abraham and the Three Angels"
(1960–1966)
Pastel, pencil, ink and fabric on
cardboard, 25.4 x 34 cm
Musée National Message Biblique
Marc Chagall, Nice

126

Photo Credits

The illustrations in this publication have been kindly provided by the museums, institutions, and archives mentioned in the captions, or taken from the Publisher's archives, with the exception of the following:
akg-images: 6, 7, 8, 31, 47, 52, 60 above, 76/77, 80, 87, 104/105, 111, 122/123, 126/127; 88/89 above and below (Electa); 51 (André Held); 41 (IAM); 19, 37, 44, 46, 60 below, 61 (Erich Lessing); 38 (Rabatti – Domingie); 112/113 (RIA Nowosti)
Artothek: 24, 120; 124 (Blauel); 42/43, 117 (Blauel/ Gnamm); 73 (Hans Hinz); 48/49 (Peter Willi)
bpk/Hamburger Kunsthalle/Elke Walford: 32/33

The Bridgeman Art Library: 27, 28, 45, 65, 66/67, 78/79, 90; 2/3 (detail), 96/97 (© Christie's Images Private collection, c/o Christie's); 14, 56, 57 (Bequest of Grenville L. Winthrop); 93 (© The Maas Gallery, London); 69 (© Peter Nahum at The Leicester Galleries, London)
Nicholas Roerich Museum, New York: 23

62/63: Photograph reproduced with the kind permission of The Russel-Cotes Art Gallery & Museum, Bournemouth

Imprint

© Prestel Verlag, Munich · London · New York, 2012
© for the works reproduced is held by the artists, their heirs or assigns, with the exception of: Marc Chagall, Maurice Denis, James Ensor, Max Ernst, Wassily Kandinsky and Henri van de Velde with VG Bild-Kunst, Bonn 2012; Salvador Dalí with Salvador Dalí, Fundació Gala-Salvador Dalí/VG Bild-Kunst, Bonn 2012

Cover: John Roddam Spencer Stanhope, *Love and the Maiden*, 1877 (detail of pp. 66/67)
Frontispiece: John William Waterhouse, *St. Cecilia*, c. 1895 (detail of pp. 96/97)
Page 27: Edward Burne-Jones, *An Angel Playing a Flageolet*, watercolor and gouache on paper, private collection

Prestel Verlag, Munich
A member of Verlagsgruppe Random House GmbH
Prestel Verlag
Neumarkter Straße 28
81673 Munich
Tel. +49 (0)89 4136-0
Fax +49 (0)89 4136-2335

www.prestel.de

Prestel Publishing Ltd.
4 Bloomsbury Place
London WC1A 2QA
Tel. +44 (0)20 7323-5004
Fax +44 (0)20 7636-8004

Prestel Publishing
900 Broadway, Suite 603
New York, NY 10003
Tel. +1 (212) 995-2720
Fax +1 (212) 995-2733

www.prestel.com

Library of Congress Control Number: 2012939409
British Library Cataloguing-in-Publication Data:
a catalogue record for this book is available from the British Library
Deutsche Nationalbibliothek holds a record of this publication in the Deutsche Nationalbibliografie; detailed bibliographical data can be found under: http://dnb.d-nb.de

Prestel books are available worldwide. Please contact your nearest bookseller or one of the above addresses for information concerning your local distributor.

Translated from the German by: Jane Michael, Munich
Editorial direction: Claudia Stäuble and Julie Kiefer
Copyedited by: Lisa Kent, Glenview
Picture editor: Franziska Stegmann
Design: LIQUID, Agentur für Gestaltung, Augsburg
Layout: Andrea Mogwitz, Munich
Production: Bianca Zippel
Art direction: Cilly Klotz
Origination: Reproline Mediateam, Munich
Printing and binding: Neografia, Martin

Verlagsgruppe Random House FSC®-DEU-0100
The FSC®-certified paper *Galaxi Keramik* was supplied by Papier-Union, Ehingen.

Printed in Slovenia

ISBN 978-3-7913-4723-3